DEVONPORT

THROUGH TIME

Derek Tait

AMBERLEY PUBLISHING

Acknowledgements

Photograph credits:
Derek Tait, Ellen Tait, Alan Tait, Steve Johnson, Maurice Dart, Andrew Barrett and Jill Trafford. Thanks also to Tina Cole and Tilly Barker.

I have tried to track down the copyright owners of all photographs used and apologise to anyone who hasn't been mentioned.

Please check out my website at www.derektait.co.uk

Bibliography

Books

Days in Devonport by Gerald W. Barker (Volumes 1–7)
Plymouth From Old Photographs by Derek Tait (Amberley, 2011)
Plymouth at War From Old Photographs (Amberley, 2012)
Plymouth Through Time (Amberley, 2010)
Plymouth at War Through Time (Amberley, 2011)
River Tamar Through Time (Amberley, 2011)

Websites

Cyberheritage at: www.cyber-heritage.co.uk
Derek Tait's Plymouth Local History Blog at: plymouthlocalhistory.blogspot.com

Newspapers

The Evening Herald
The Western Morning News

First published 2012

Amberley Publishing
The Hill, Stroud
Gloucestershire, GL5 4EP

www.amberley-books.com

Copyright © Derek Tait, 2012

The right of Derek Tait to be identified as the Author of this work has been asserted in accordance with the Copyrights, Designs and Patents Act 1988.

ISBN 978 1 4456 0774 0

British Library Cataloguing in Publication Data.
A catalogue record for this book is available from the British Library.

Typeset in 9.5pt on 12pt Celeste.
Typesetting by Amberley Publishing.
Printed in the UK.

Introduction

The community of Devonport grew up around the dockyard. The yard was established in the reign of William III and was originally called Plymouth Dock. Built in the 1690s, it wasn't until 1843 that the authority was given to change the name from Plymouth Dockyard to Devonport Dockyard.

During the early 1700s, a small settlement to house workers was built around the dock. By 1733, the population had grown to 3,000 and by 1811 the population had increased greatly to 30,000. By now, the popular market was in operation selling poultry, milk, butter, fruit and vegetables.

The residents were unhappy with the name 'Plymouth Dock' as it made the town sound like it was part of Plymouth itself so a petition to King George IV requested in 1823 that the town's name be changed to Devonport. To celebrate the new name, a column was built next to the newly-built town hall in Ker Street.

Devonport was one of the 'Three Towns' (including Plymouth and Stonehouse) that merged in 1914 before becoming the city of Plymouth in 1928. The area suffered much in 1941 during the heavy bombing of the Second World War. Much of Fore Street was destroyed or severely damaged as were the surrounding streets. Devonport High School for Girls took a direct hit, the gasometer at Keyham was set alight and the dockyard also came under attack. Today, it's hard to imagine the grand old buildings that once stood in Fore Street. The Forum survives as does the Midland Bank and the old market building but most has gone forever. Some of the area's most popular streets have been lost altogether.

Much rebuilding work took place after the war and more modern houses and flats appeared. Clearance work obliterated whole streets. Areas such as Cornwall Street and Cannon Street, originally built in the 1700s to house dockyard workers, were redeveloped. The area around Cornwall Street was again cleared in the late 1990s and new dwellings were built.

Today, there's much to see walking around the streets of Devonport. Many of the old buildings still survive and parts of the area are still laid out as they were 100 years ago. The long stretch of Albert Road takes you past such places as the old Aggie Weston building (now Latitude 52), past many old shop fronts and well-loved public houses up towards the Higher Elementary School at Keppel Place. Travelling along the back streets allows you to walk over cobbled paths that have been in existence for over 100 years and have been walked endless

time by local residents both past and present. There is also much to see walking through Devonport Park which has recently seen a great deal of restoration work. Devonport is currently going through an incredible renovation with new homes being built in both Ker Street and the reclaimed Fore Street. For many years, Fore Street stood within the walls of the dockyard but the area has been opened up and is part of a vast regeneration project as are many other parts of Devonport. The Guildhall has been repaired and repainted and the whole area has generally been tidied up. St Aubyn Church has also been renovated and is now used as the main library in Devonport.

I loved Devonport as a boy in the 1960s but, today, there seems to be a new, more vibrant, Devonport emerging.

I've tried to capture as much of the old and new Devonport as I can within the pages of this book and I hope it will prove an interesting and enjoyable read.

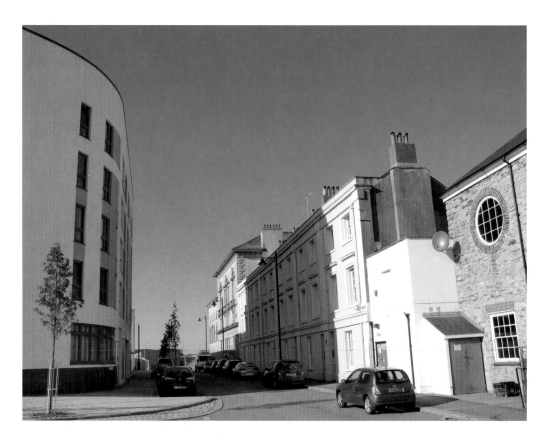

The Old and New Buildings in Duke Street

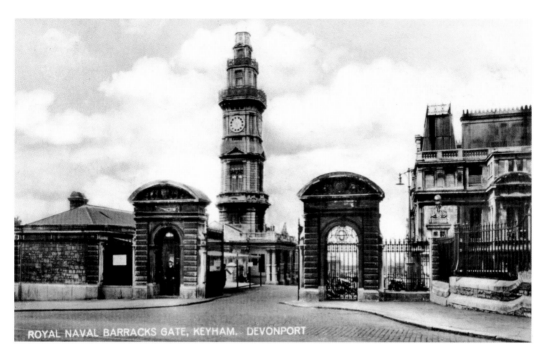

ROYAL NAVAL BARRACKS GATE, KEYHAM. DEVONPORT

The Royal Naval Gate at Keyham

The Royal Naval Barracks at Keyham were originally known as HMS *Vivid,* but were renamed HMS *Drake* in 1934. The clock tower seen in both photographs was built in 1896. For many years, this was the main entrance for people visiting the annual Navy Days event. Security has been heightened in recent times and, today, the gates are patrolled by armed police.

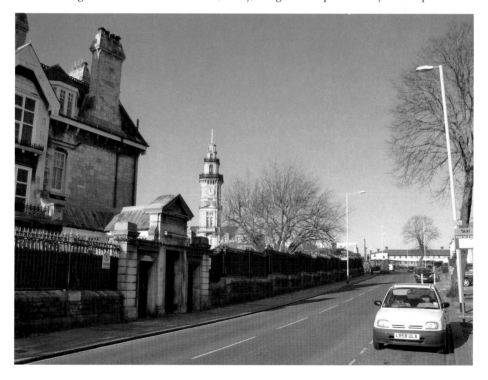

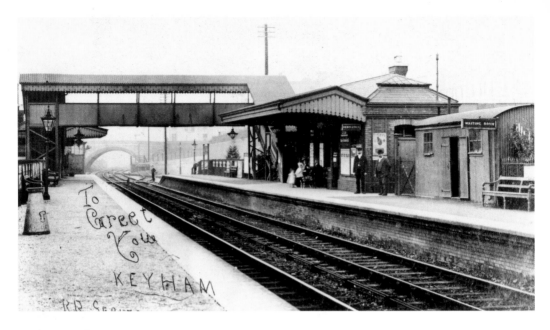

Keyham Station

The station was opened in 1900 by the Great Western Railway. It was once well-used but today, although it remains open, it is unstaffed and eerily quiet at the best of times. Much of the character of the old station, seen in the earlier photograph, has been lost forever. The shelters and waiting room are long gone.

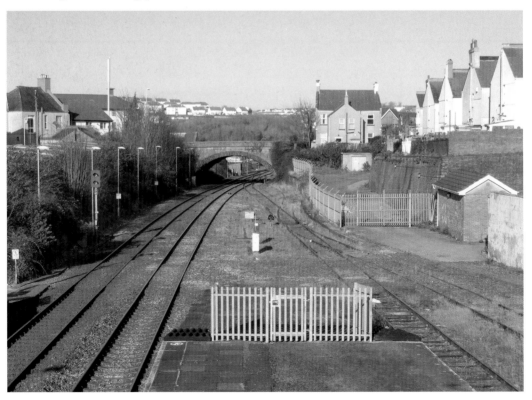

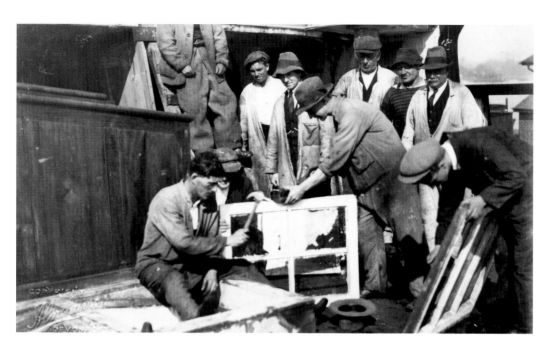

Carpenters Working within the Dockyard

Edward Dart and his colleagues can be seen working in the dockyard in the older photograph. The first stone dock at Devonport was completed in 1698 and covered 24 acres. Originally known as Plymouth Dockyard, its name was changed to Devonport Dockyard in 1843. Today, the dockyard is operated by the marine division of Babcock International.

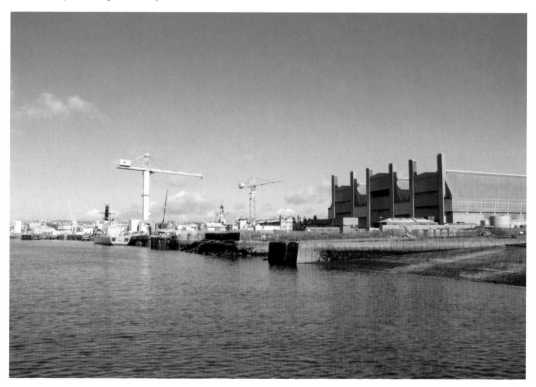

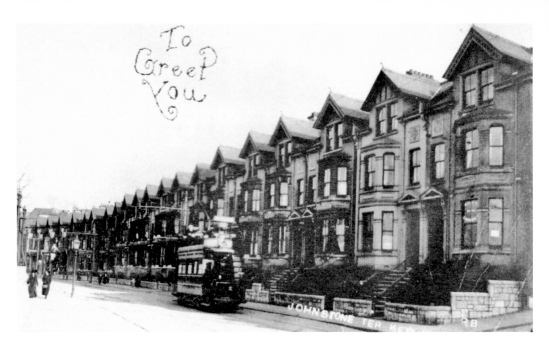

A Tram at Johnston Terrace

Johnston Terrace, near to the gate at HMS *Drake*, appears to have changed little over the years. The trams are long gone and modern lighting has been installed but the buildings are still instantly recognisable. Several shops and a social club can be seen at the far end of the later photograph.

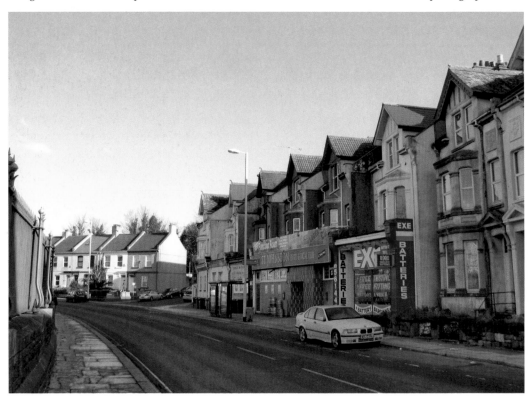

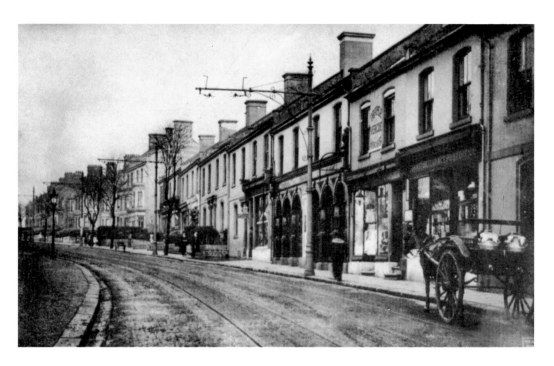

A Horse and Cart at Saltash Road

The Royal Naval Arms appears in both photographs and has been very popular with sailors over the years. A horse and cart with milk churns can be seen on the right of the earlier photograph. Many of the buildings still remain but the tramlines and quiet road have long since disappeared.

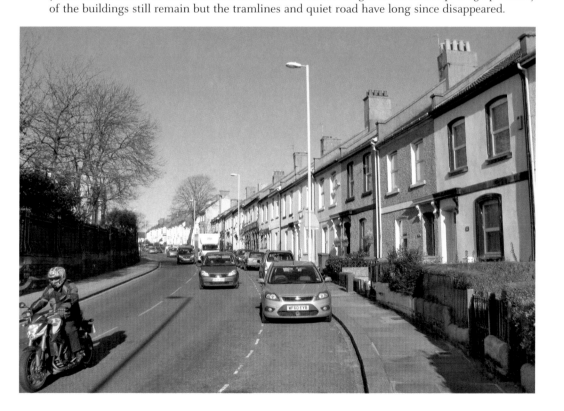

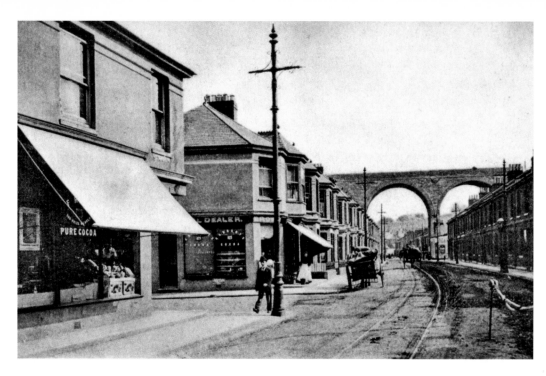

The Viaduct at St Levan's Road

The older photograph shows a view of St Levan's Road in Morice Town. In the distance can be seen the Ford Viaduct which was demolished in 1987. The carnival procession used to pass this way in the 1930s before the Second World War. The later photograph shows the railway crossing today.

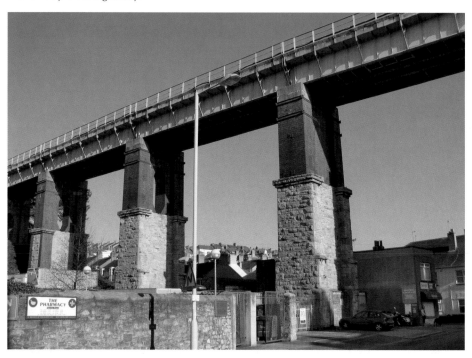

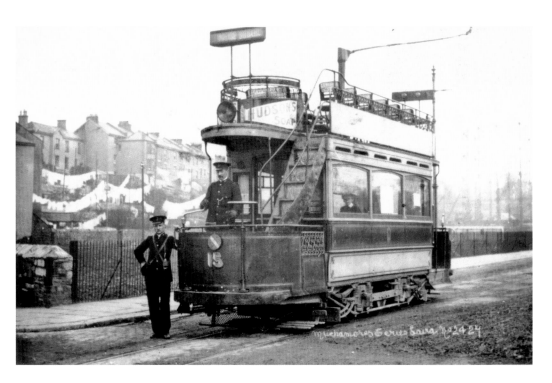

A Tram by the Gasometers in St Levan's Road

Car 15 can be seen with its driver and conductor posing for the camera. There are a couple of passengers including a young boy who is looking out of the window at the photographer. The frame of the gasometer can be seen on the far right of the picture. The later photograph shows the scene today.

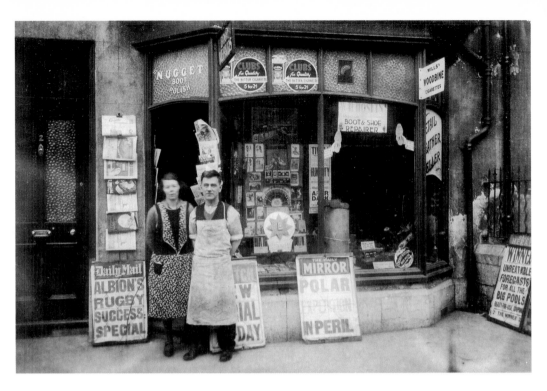

Hoskin's Newsagent at Atherton Road

The older photograph shows the proprietors of Hoskin's newsagent and general store at Atherton Place. From the newspaper hoardings, Plymouth Albion have been successful, the Polar expedition is in peril and there is 'an unbeatable forecast for all the big pools'. Those were the days when winning the pools was the equivalent to winning the lottery.

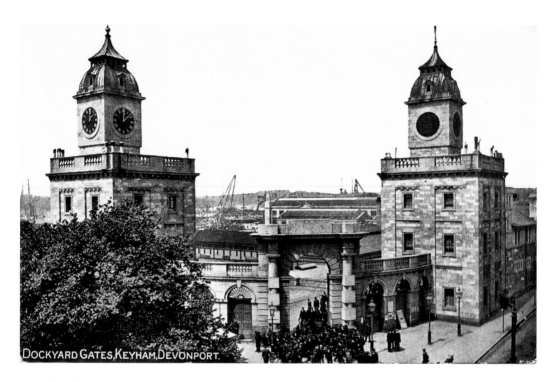

DOCKYARD GATES, KEYHAM, DEVONPORT.

The Dockyard Gates at Keyham

The dockyard gate at the bottom of Albert Road, shown in the older photograph, was closed in September 1966 and a new gate was opened nearby. The structure nearest the road now houses the clock that was once part of the other tower. One of the huge Babcock Marine hangars now dominates the scene and a newer wall covers the original entrance.

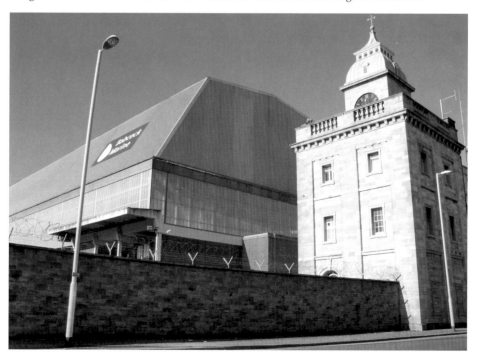

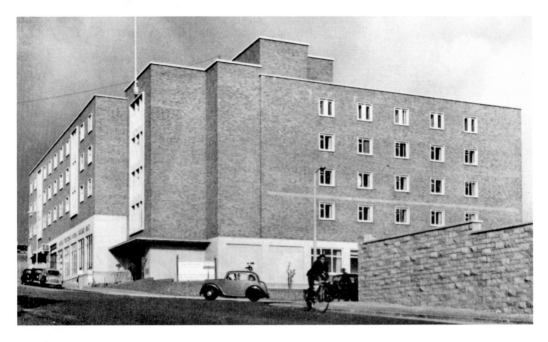

Aggie Weston's Royal Sailors Rest at Albert Road

The Aggie Weston building in Albert Road opened in December 1959. The previous Aggie Weston's in Fore Street had been destroyed in the Blitz. The accommodation was for servicemen and cost three shillings and six pence a night. The building closed in 2001 and reopened as accommodation for students in 2003. Today, it houses the luxury apartment block, Latitude 52.

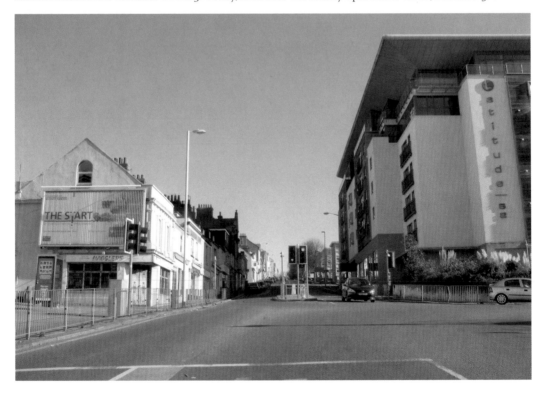

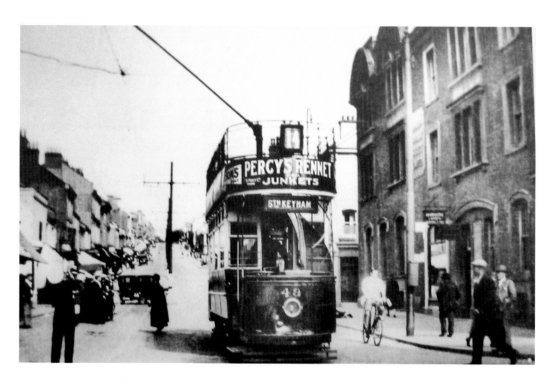

A Tram Travelling Down Albert Road
Tram accidents weren't common but one runaway tram in Albert Road veered dangerously as the driver stayed onboard desperately trying to regain control. The tram's arm left the overhead cables and smashed through three windows. The tram jumped off the rails at the bottom of the road before hitting a shelter. Luckily, no-one was seriously injured.

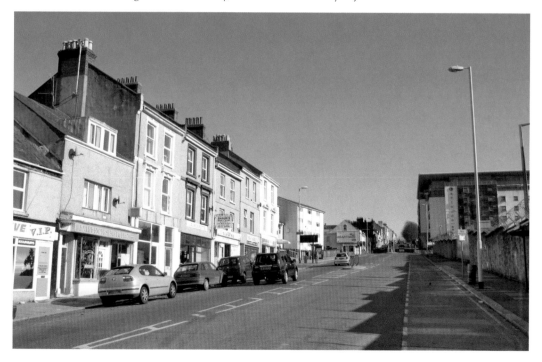

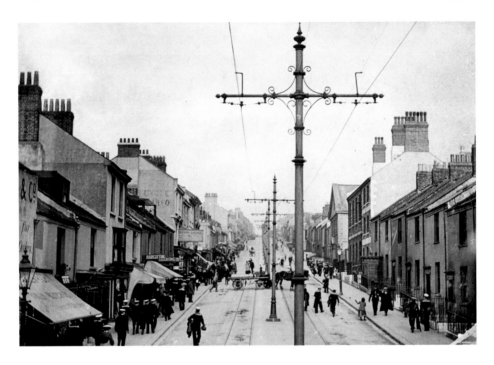

Many Sailors at Albert Road
There is much activity in the older photograph and naval officers and sailors can be seen making their way up Albert Road. A horse and cart blocks the way and a policeman appears to have apprehended someone on the right of the picture. The road was also known as 'Navy Row'.

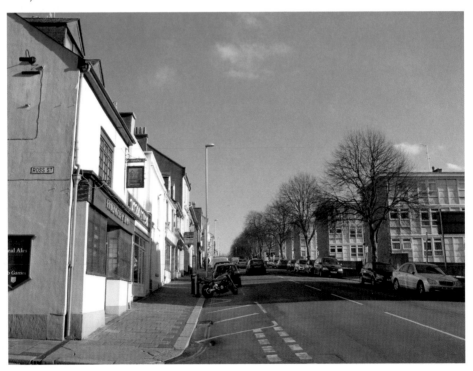

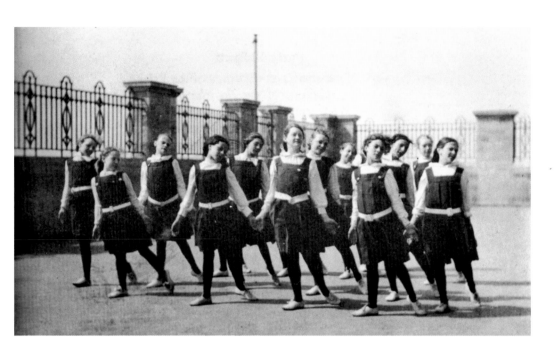

Schoolgirls at Keppel Place
Girls can be seen dancing on the flat roof of the Higher Elementary School at Keppel Place. The photograph was taken in 1914. The girls were allowed to use the roof for recreation but the boys had to use the basement. The headmistress at the time was a Mrs Tierney.

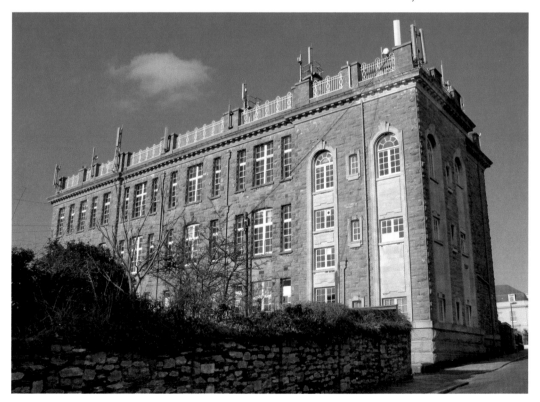

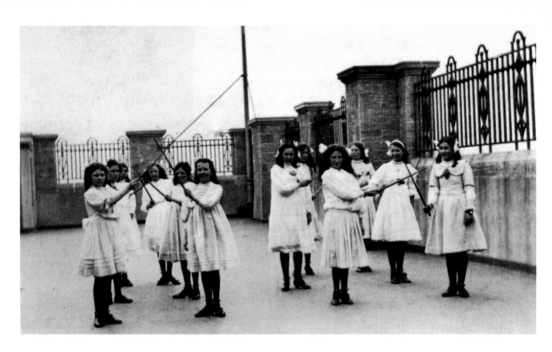

Higher Elementary School in Keppel Place

A male teacher was employed at the Higher Elementary School in Keppel Place to teach the girls 'stick drill', which was similar to the drill carried out later by Royal Naval Artificer Apprentices within the building during the Second World War. The older photograph shows the girls in 1912 performing the drill.

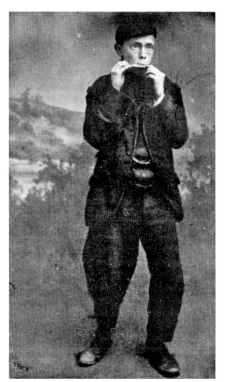

Pennycross Bill at Morice Town

'Pennycross Bill' played the harmonica and was well-known to the people of Devonport during the early 1900s. He also played the Jew's harp and the penny whistle. At the end of his performance, he would quickly take off his cap to collect pennies from the appreciative crowd. Another local character was 'Colonel' who lived close to Morice Town School. In the 1930s, he would entertain the many people who gathered in Devonport Park during carnival week.

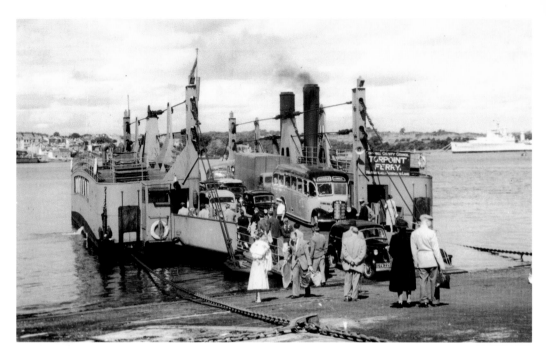

Passengers Boarding the Torpoint Ferry
Many passengers wait as cars and buses leave the Torpoint Ferry in the 1950s. On board is a coach belonging to Marigold of Lanner, a company belonging to a Mr Newton Trewren. A naval ship is moored nearby. Mothers who couldn't afford to take their children on trips to the Moors or the seaside would instead take them over to Torpoint on the ferry and spend a day relaxing on the area known as the Lawn.

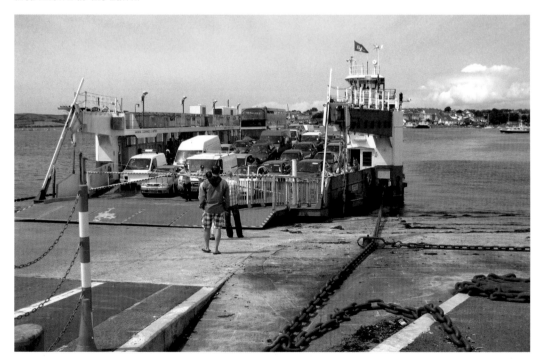

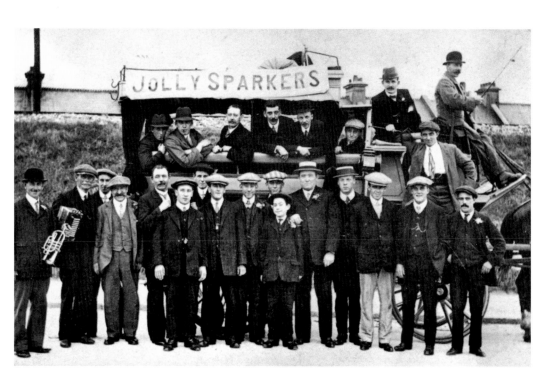

The Jolly Sparkers

The Jolly Sparkers entertained the people of Devonport and one member, Albert Haderly, would strum his banjo for the passengers of vehicles queued for the Torpoint Ferry. He also busked to crowds waiting at the many cinemas and theatres in Devonport and was very well-known in the area. He was rewarded with loose change.

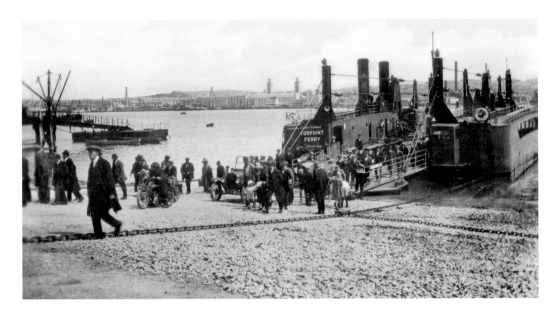

The Busy Ferry Arriving at Torpoint

Many workers, together with various early vehicles, alight from the ferry at Torpoint. Plymouth's dockyard can be seen in the distance. The ferry has been running from Torpoint to Morice Town since 1791. Rowing boats guided it until 1821 when a steamboat was introduced. It couldn't cope with the strong currents so chains were laid to guide the ferry.

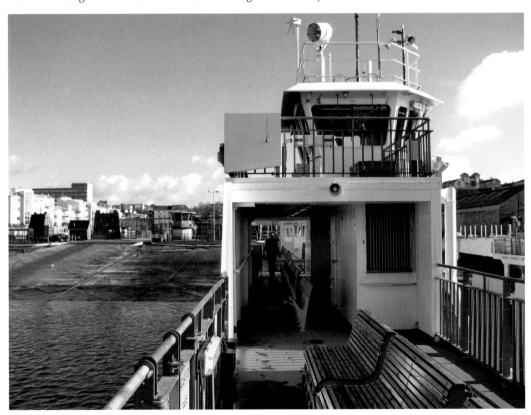

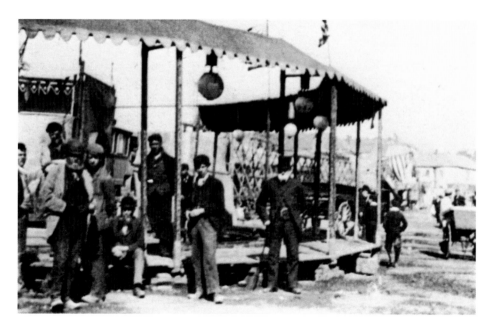

The Fairground at Ferry Road

The earlier photograph shows a Victorian scene showing the fairground at Devonport. In October 1934, Whitelegg's opened a fair at the bottom of Devonport Park adjoining New Passage Hill. Open at weekends, popular rides included the Dodgems and one called the 'Thriller'. Whitelegg's also ran another popular venue at the Olympia in Union Street. Their rides were listed as the Speedway, the Waltzer, Noah's Ark, Jelly-Wobble and Mickey Mouse Hoopla.

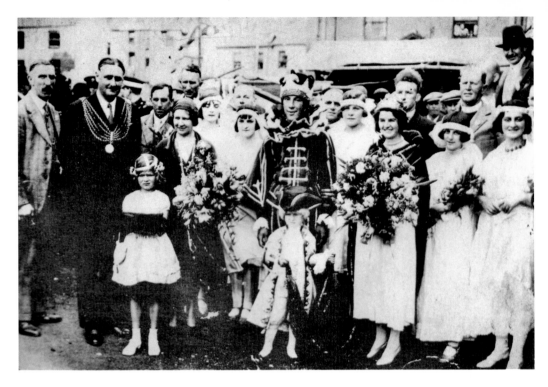

The Carnival Queen at Pottery Quay

Olive Harris was the Carnival Queen, shown here at Pottery Quay, in 1931. The Carnival King that year was Harry Swabey. She is accompanied by many maids holding garlands of flowers. On the left of the picture is the Lord Mayor, Clifford Tozer. The 'Queen' would be crowned each year at Devonport Park.

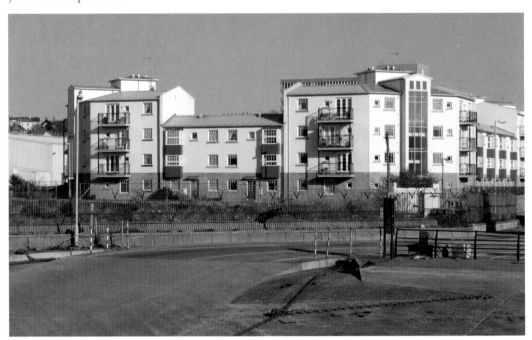

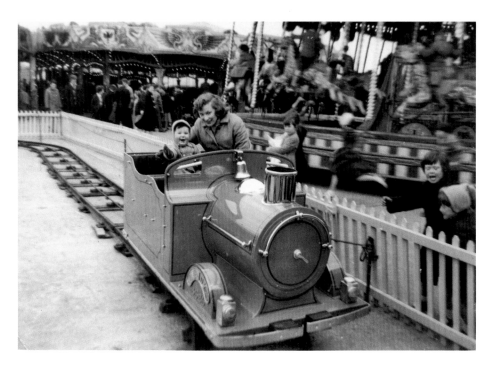

Alan and Ellen Tait at the Fair at Devonport Park

There's all the fun of the fair in this 1950s shot taken in Devonport Park. An ornate carousel, complete with many horses, revolves on the right of the picture while, in the background, people queue up to go on the dodgems. The train looks very similar to the Gus Honeybun trains used at West Hoe.

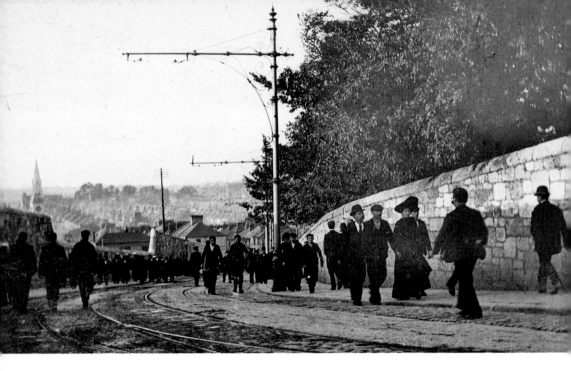

New Passage Hill Heading Down Towards Ferry Road

New Passage Hill leads up from the ferry towards Marlborough Street, close to Devonport Park. A dockyard gate is passed on the way and many sailors and dockyard workers once used this route. In the older photograph, long-gone tramlines and overhead cables can be seen heading down towards the ferry.

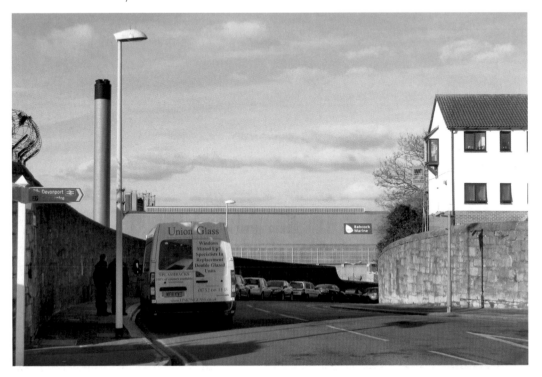

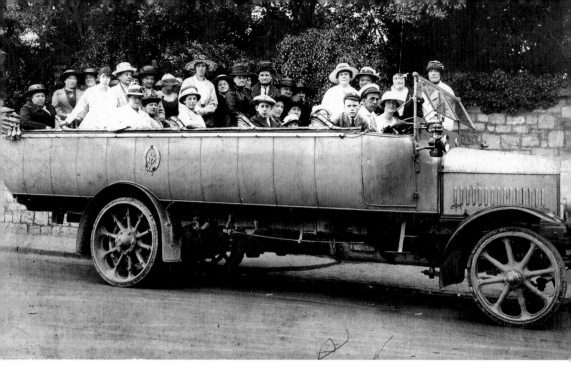

A Charabanc Outing from St Paul's Church in 1924
Charabanc outings became very popular during the 1920s and the huge cars used carried many people. There are thirty passengers on this outing. St Paul's Church used to stand opposite the Royal Fleet Club on the site of the small car park near to Marlborough Street but there is no trace of it left today.

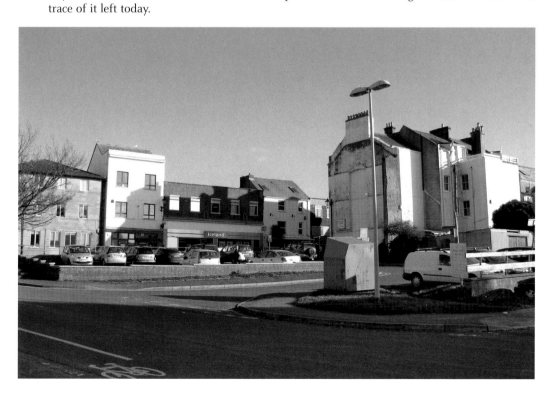

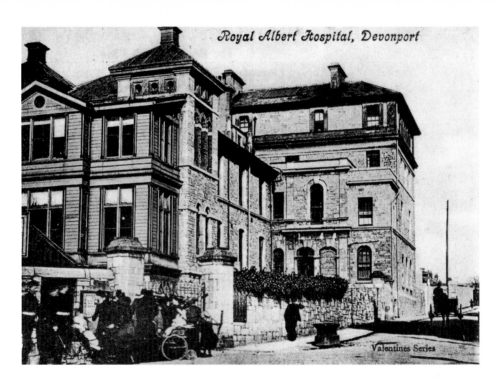

The Royal Albert Hospital

The hospital was opened on 1 December 1863. A fête and bazaar took place on the day to celebrate the event. The nursing staff collected money in 1918 so that electric lighting could be installed. The hospital closed in 1981 when Derriford Hospital opened. Today, houses occupy the site but some features of the hospital have been retained.

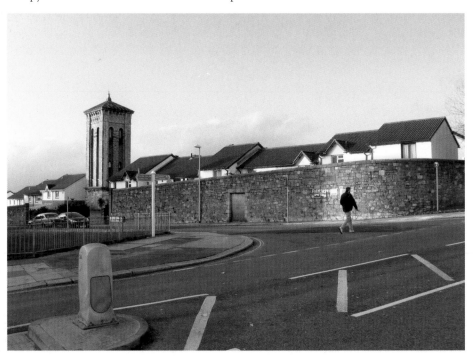

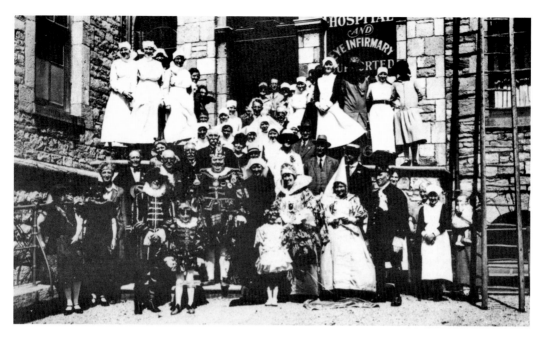

Putty Philpotts at the Royal Albert Hospital

Putty Philpotts can be seen dressed as Carnival King at the Royal Albert Hospital in 1928. His 'Queen' was Edith Mayne. Funds raised at the carnival were used to support the hospital. Parts of it still survive although most was demolished to make way for a new housing estate.

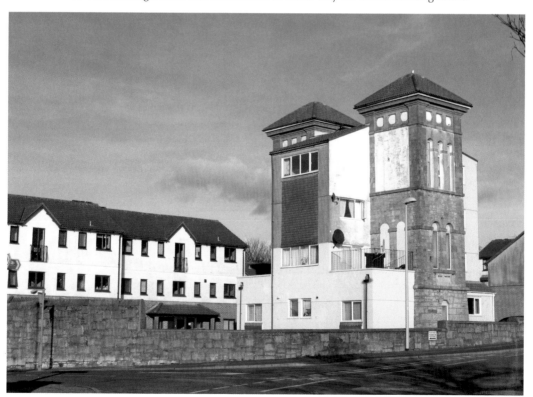

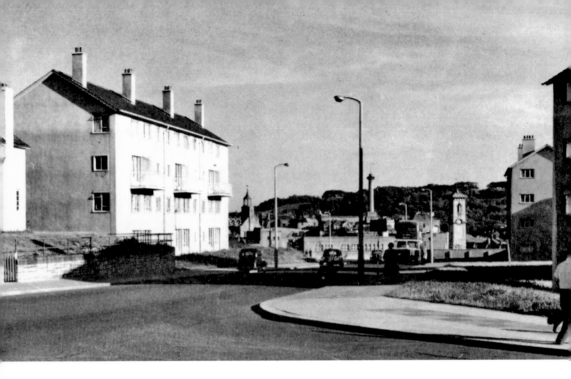

Park Avenue

The flats at Park Avenue have changed little over the years. In the older photograph, taken in the late 1950s, the Guildhall, Column and the market can be seen in the background. The later photograph shows newer developments in the distance but the Column by the Guildhall can still be seen.

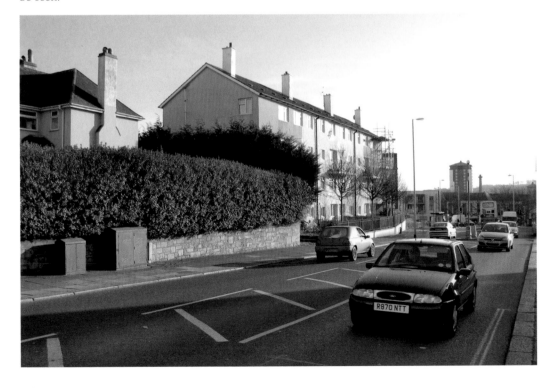

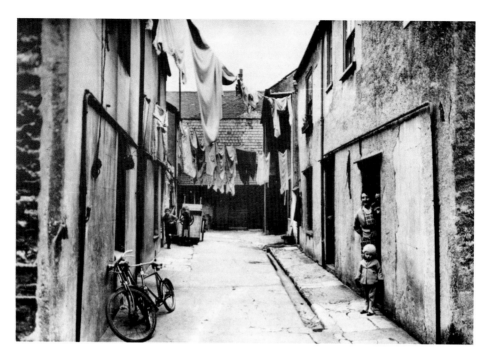

Washing Day at Granby Street

The Granby Square army barracks were built in the area in 1757. They were named after Lieutenant General John Manners, the then Marquis of Granby. The barracks were upgraded in 1860 and became known as the 'New Granby Barracks'. After the army left, the plot was redeveloped in the 1960s and residential flats were built.

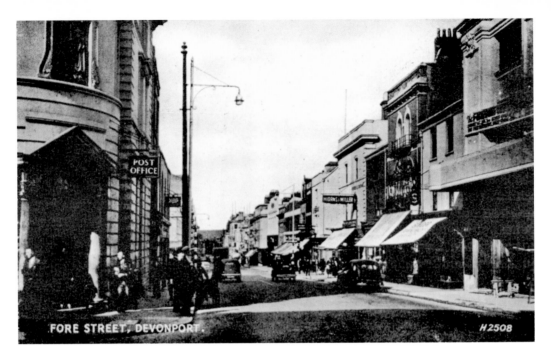

FORE STREET, DEVONPORT. H2508

The Post Office at Fore Street

The ornate post office was decorated with symbols of postal despatch and the produce of England. During the Second World War, the Local Defence Volunteers, who would later become the Home Guard, defended the post office during the night hours. The six men on patrol had a rifle each but only one clip of ammunition between them.

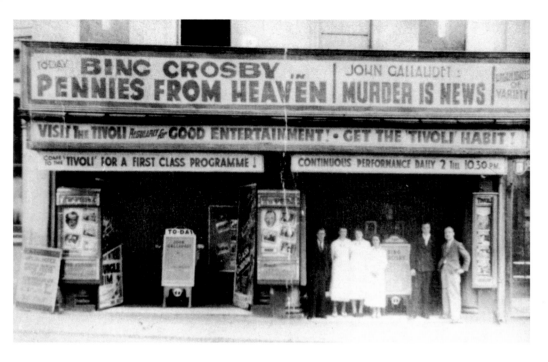

The Tivoli Theatre in Fore Street

The Tivoli stood at number 8 Fore Street diagonally across from where the Forum would later stand at numbers 111–113. It was so named because the design of the nearby post office was copied from the Tivoli in Rome. The older photograph shows that the latest blockbuster at the time was *Pennies From Heaven* starring Bing Crosby.

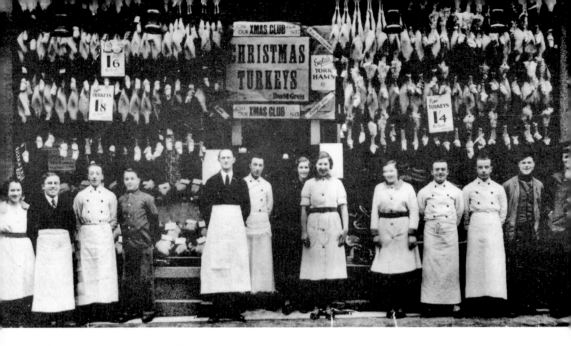

Christmas Turkeys at David Greigs, Fore Street
David Grieg's shop stood at number 109 which was next to Singers which joined the Forum Cinema. The photograph shows the staff of the shop and the many turkeys that were for sale at Christmas time. They start at 1/4*d*. Much of the area was destroyed in the Blitz of 1941.

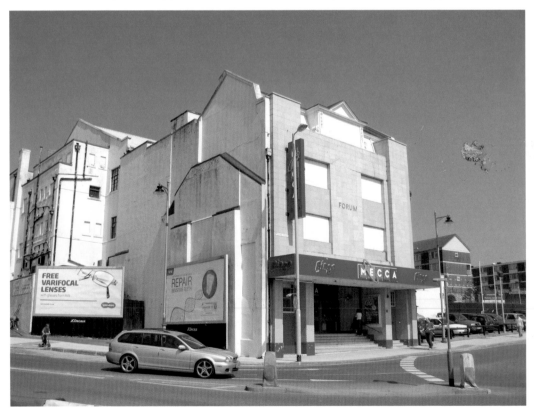

Queen Marie Presented with Violets in Fore Street

In the earlier photograph, Queen Marie of Rumania can be seen visiting Devonport in 1925. In the background are the dockyard gates in Fore Street.

A policeman lifts the small girl so that she can present her flowers. The Queen's father had previously laid the foundation stone for Smeaton's Tower on the Hoe as well as laying the foundation stone of the Naval Orphanage at Albert Road.

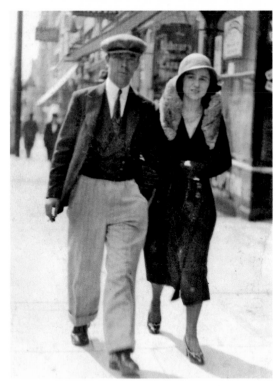

A Couple Stroll along Fore Street

The older photograph shows John Addelsee and Doris Chubb passing the library in Fore Street in the early 1930s. John lived in James Street until 1935 when he married Doris. The library was at number 4, next door to the Railway Hotel. The later photograph shows the preserved Midland Bank which stood further down Fore Street at number 99.

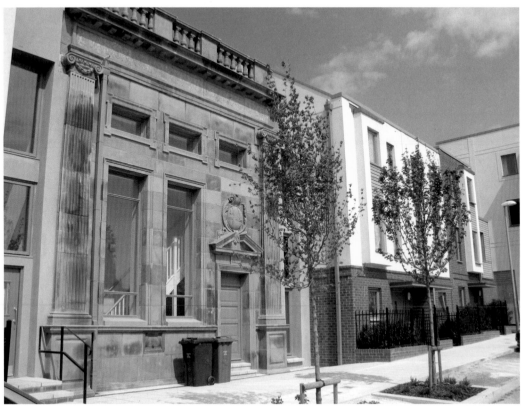

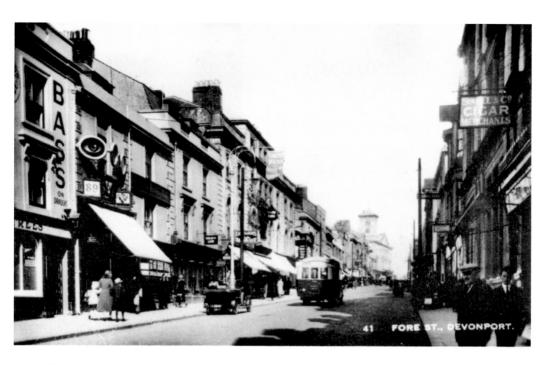

The Two Trees in Fore Street

The Two Trees stood at number 85 and beside it was Bateman the Optician. The flag in the picture advertises Timothy White's which was joined to Lipton's. The bus is heading towards the junction at Lambert Street. The tower in the picture belonged to the Electric Cinema and was similar to the one that belonged to the market although it didn't have a clock.

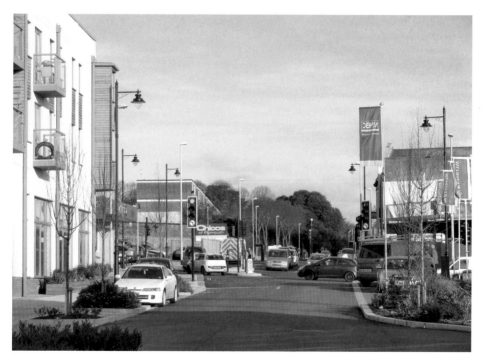

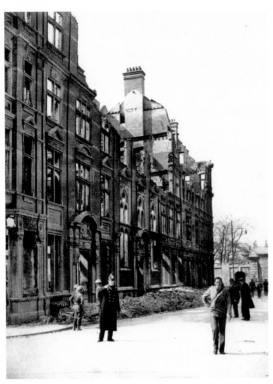

The Blitzed Aggie Weston Building in Fore Street
The building originally housed the Co-operative but was rented by Agnes Weston in 1874 as a sailors' rest. It included a hostel and a restaurant. It stood at number 56 where Fore Street joined Catherine Street, close to the dockyard gate. It was destroyed during the Blitz of the Second World War.

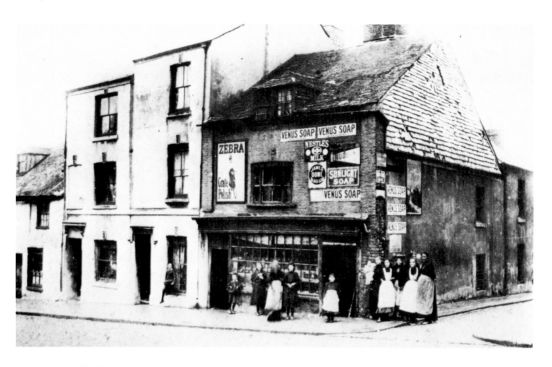

A Small Shop at James Street

The small shop in James Street had many interesting tin advertising signs including ones for Nestlé's Milk, Sunlight Soap, Zebra Grate Polish, James Dome Black Lead, Hudson's and Venus Soap. All the occupants of the building can be seen posing for the photographer. All these buildings have now long gone and the later photograph shows the view looking towards the flats at James Street today.

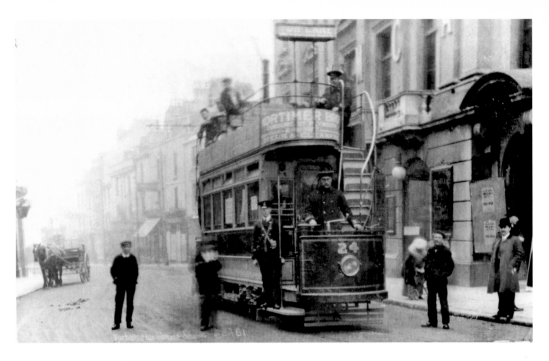

A Tram at the Top of Fore Street
The number 24 tram can be seen parked by the old YMCA building in Fore Street. The YMCA moved to St Aubyn Street in 1886 but the letters remained on the building for many years afterwards. The tram is heading towards Tor Lane and is decorated with an advert for Mortimer Brothers.

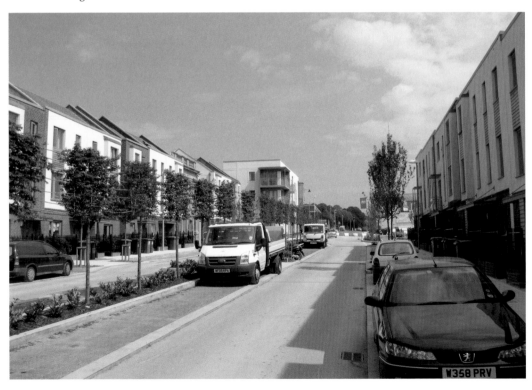

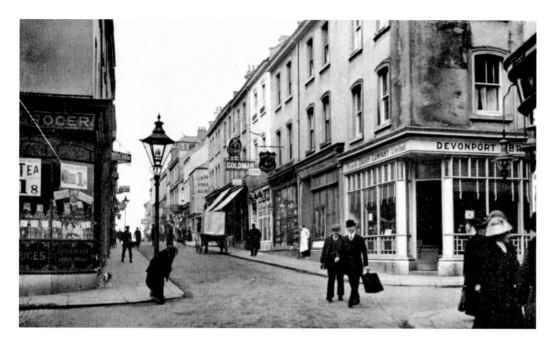

A Busy Marlborough Street

Marlborough Street is instantly recognisable today. Many of the buildings survive although the businesses that traded from them are long gone. In the older photograph, a shop belonging to the Plymouth Dairy Company can be seen on the right. On the left is a grocer's selling tea and other items. The lamp would have been lit by a lamplighter with a long pole each evening.

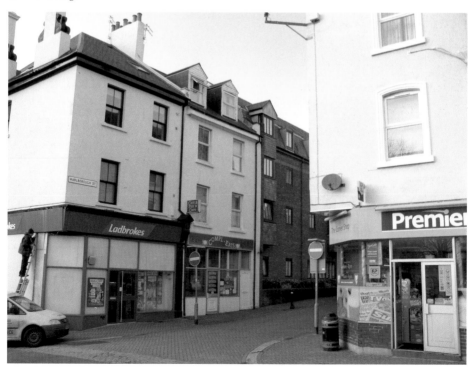

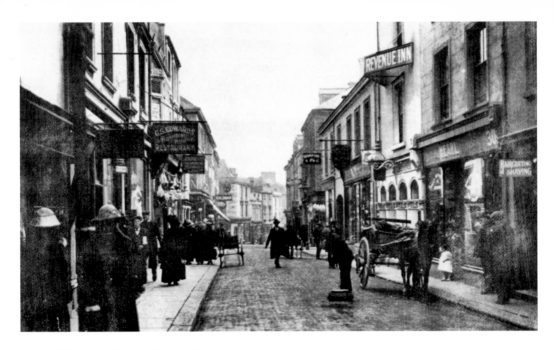

The Cobbled Road in Marlborough Street

Today, the cobbles in Marlborough Street have disappeared but have been replaced by a more modern version. Newer lamps, made to look like the original ones that once lit the street, have been installed. A man sweeps away horse droppings from the middle of the street in the older photograph and a horse and cart wait nearby.

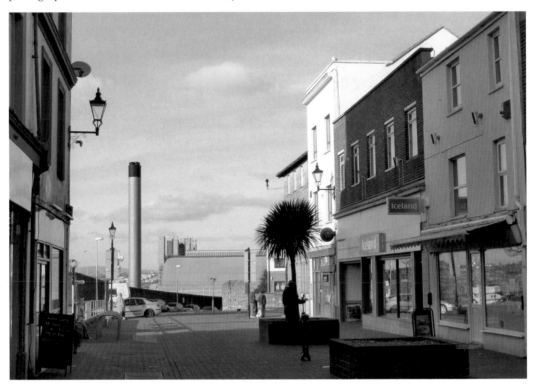

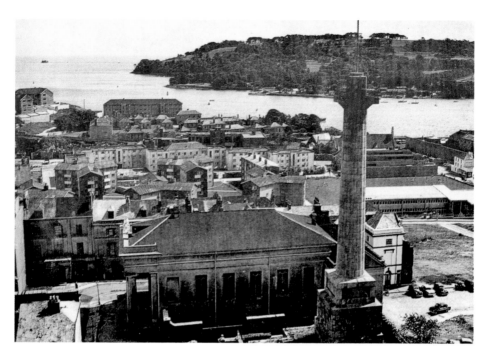

The Column and Guildhall Looking Towards Mount Edgcumbe
Known as the 'Devonport Acropolis', John Foulston designed the buildings using different forms of architecture. The nearby Odd Fellows Hall, which was originally the Civil and Liberty Library, was built in the Egyptian style in 1823. The Guildhall was built as a copy of the Parthenon in Greece and the Column was built of Cornish granite in the Doric style.

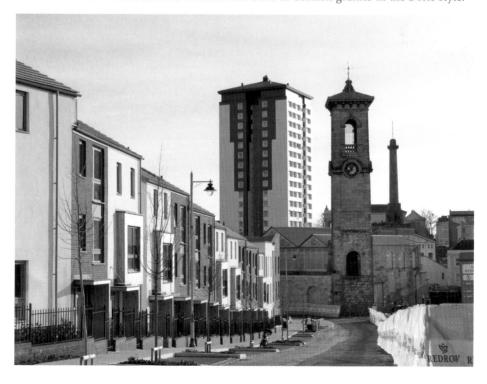

43

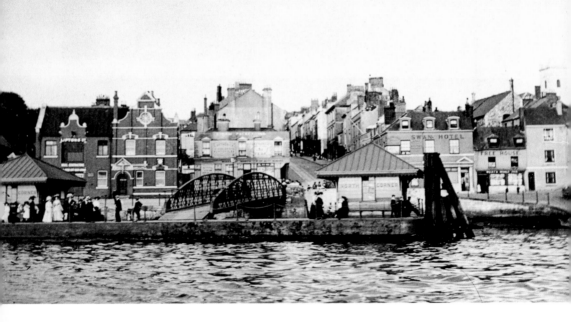

Passengers Wait at North Corner

In the older photograph, North Corner can be seen at the bottom of Cornwall Street. In the background are Lipton's, the Steam Packet Inn and the Swan Hotel. A ferry service ran from North Corner to Saltash where people would attend the many tea gardens there. Today, much of the area is obscured from the river by the dockyard bridge which was opened in 1963 and links the north and south dockyard.

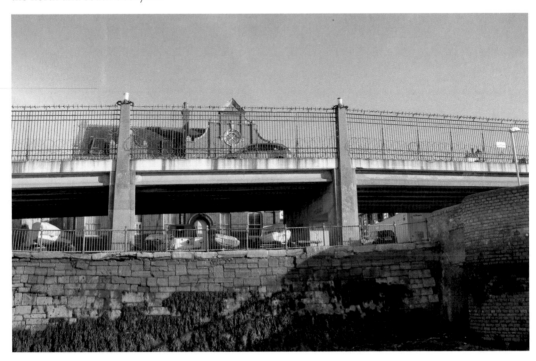

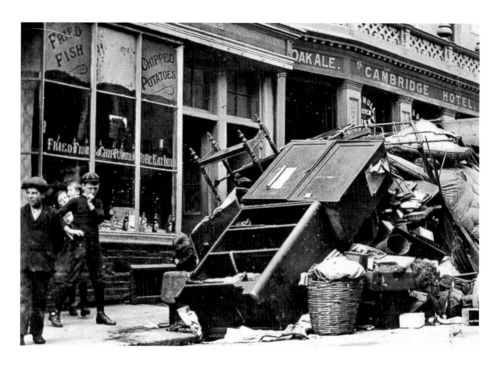

An Eviction in Cornwall Street

A family's possessions are thrown out in the street in the earlier photograph. The Cambridge Hotel which was at 54 Cornwall Street can be seen in the background. Beside it was a fish and chip shop. Cornwall Street has changed completely in recent years and, as part of the regeneration of Devonport, many new houses have been built in the area.

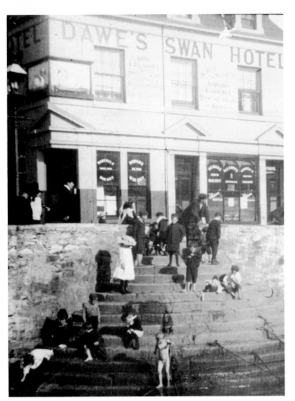

Paddling at North Corner
Children play on the steps in front
of Dawe's Swan Hotel in the older
photograph. Adverts for Dewar's
Perth Whisky, Allsopp's Brown Ale
and Bass can be seen on the windows
of the establishment. The building
still stands on the corner of Cornwall
Street and Cornwall Beach but has
been closed for business for many
years.

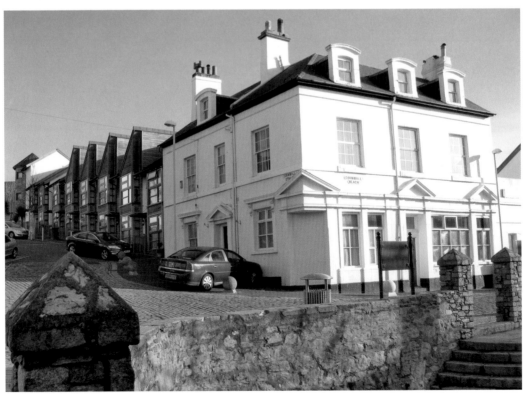

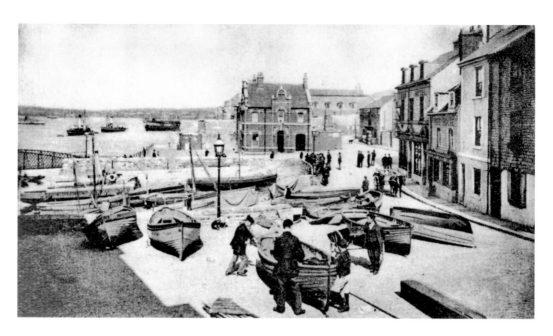

Fishing Boats at North Corner

Fruit from the Tamar Valley including plums, cherries, strawberries and apples would be offloaded at the jetty at Cornwall Beach. Dray horses would pull the produce on carts slowly up the nearby steep hill destined for the popular Devonport Market. Cattle and vegetables would also be brought by boat to North Corner.

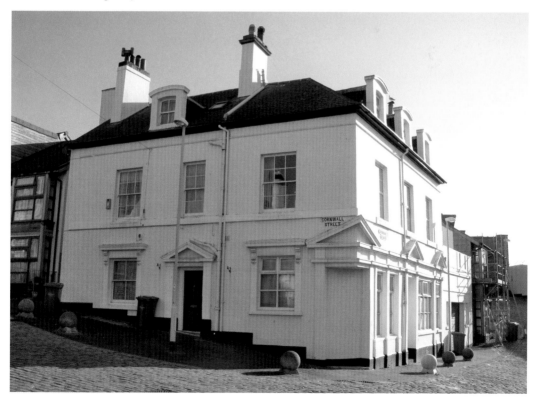

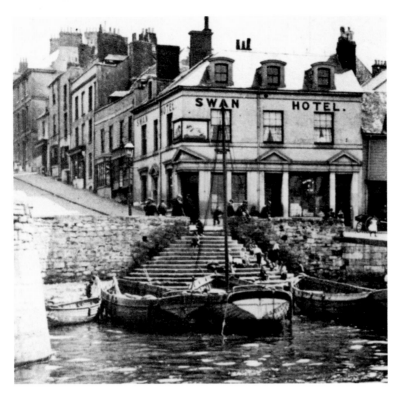

The Swan Hotel
Watermen in their
boats would collect
workers from
the steamers and
row them ashore.
One well-known
waterman was
'Peggy' Rickard
who always wore a
skipper's hat while
working. After
produce from
the Tamar Valley
was unloaded, the
boats would be
used as pleasure
ferries to take
passengers to Looe,
Cawsand, Calstock,
the Eddystone,
Weir Head and the
River Yealm.

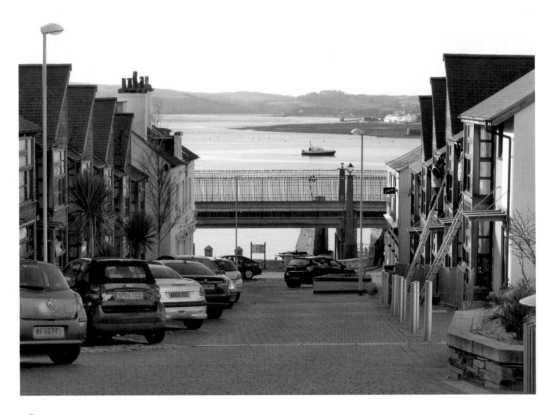

St Aubyn's Church

St Aubyn's Church stands on Chapel Street. It was built in 1771 and was damaged during the Blitz of 1941. It was re-opened in 1952. Recently, it has undergone much renovation work and today, part of it has been converted into Devonport's main library. A place of worship is also still contained within the building.

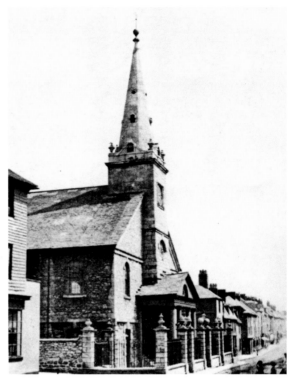

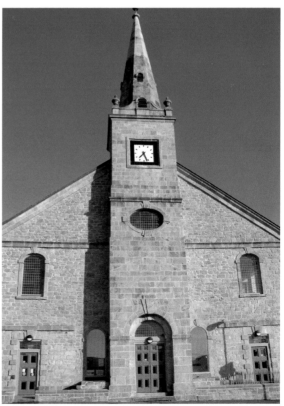

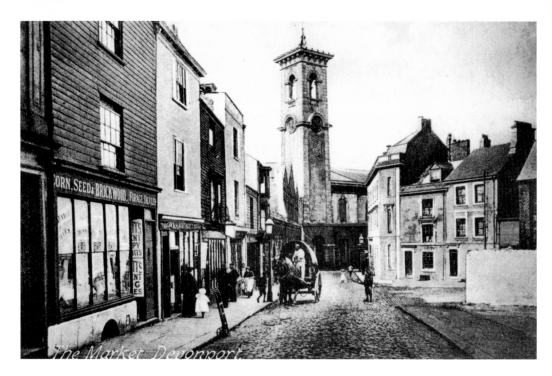

The Market

The market was not only popular with the residents of Devonport but also with Plymothians. The market first appears in records in 1812 but it had been in existence since the 1700s. It was damaged by bombing in 1941 but survived the Blitz. It fell within the confines of the dockyard in 1956. Today, the market building is undergoing repair work as part of the regeneration of the area.

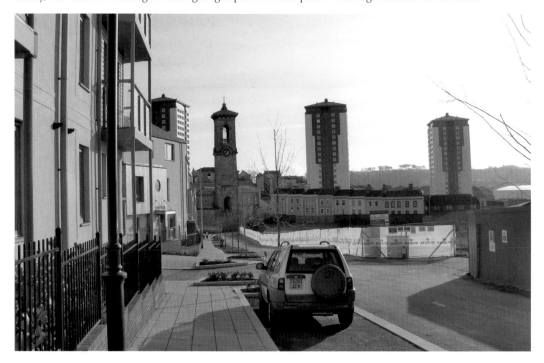

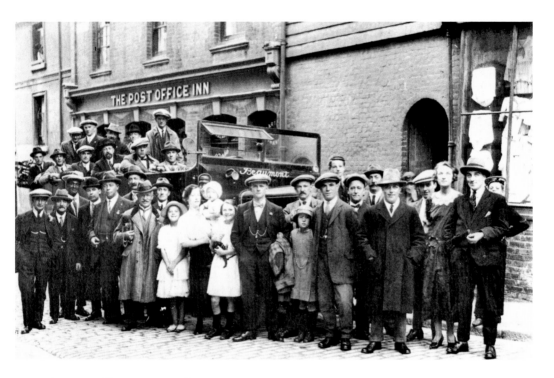

The Post Office Inn at Market Street
A group can be seen gathered in Market Street outside the Post Office Inn. The street ran down from St Aubyn's Church towards Catherine Street. All the people in the photograph are dressed up ready to go on an outing. One small girl has brought her pet kitten. Trips in a 'motor' were very popular at the time.

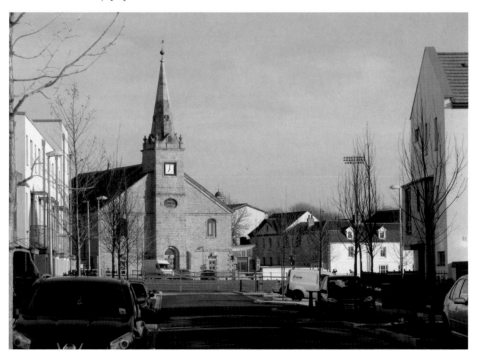

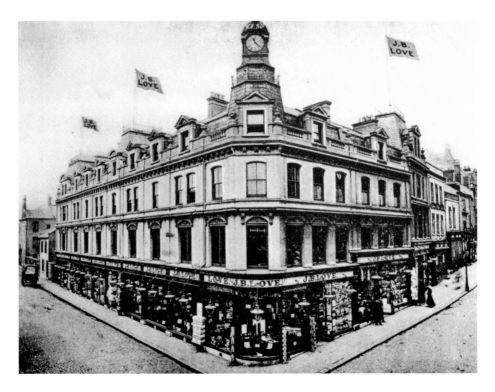

Jimmy Love's Emporium in Catherine Street

The building in the older photograph stood at the bottom of Catherine Street where it joined Edinburgh Street. The flags flying high above it advertised J. B. Love's Emporium. The shop was huge and very popular with the people of Devonport. It rivalled Tozer's and Bould's. Unfortunately, it was destroyed during the Blitz.

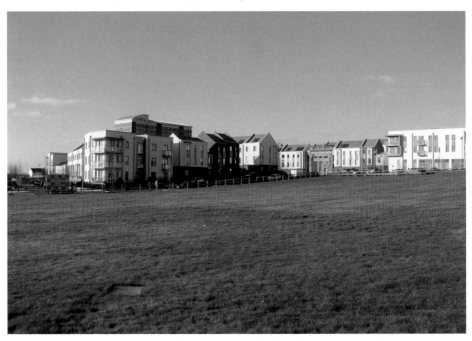

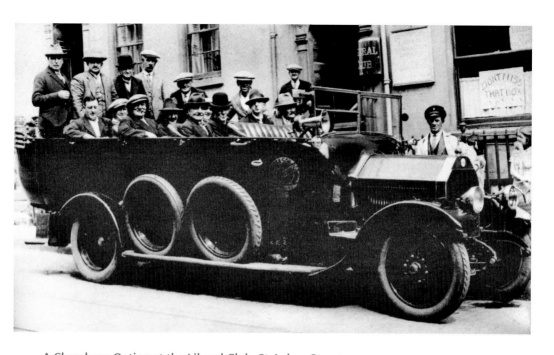

A Charabanc Outing at the Liberal Club, St Aubyn Street

Fifteen men prepare to leave on a charabanc outing from the Liberal Club in St Aubyn Street. A notice in the window reads 'Don't Miss That Box', which maybe refers to a forthcoming election. St Aubyn Street ran from Fore Street towards Catherine Street running parallel with Chapel Street. The street is long gone and the area today is grassed over.

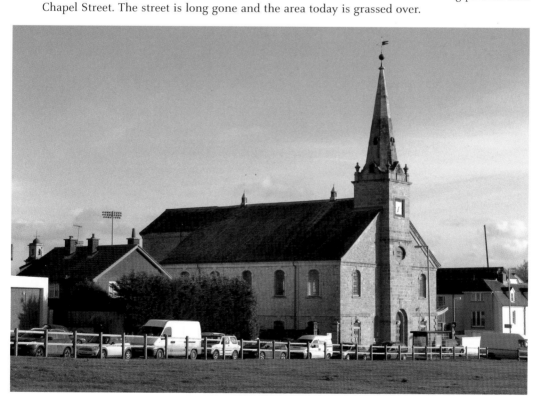

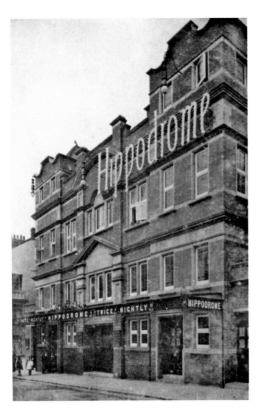

The Hippodrome in Princes Street
The Hippodrome opened as a music hall
in 1908. By the 1920s, it was also showing
the latest silent films as well as live
entertainment. On Christmas day of 1929,
it showed its first sound film which was
Broadway Melodies. The Hippodrome was
destroyed in the Blitz but would have stood
where the red and white Salvation Army
building stands today.

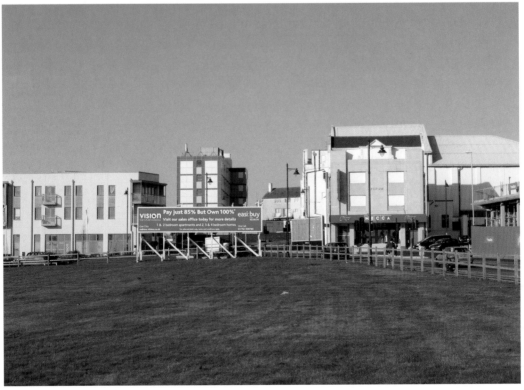

Nelson House at St Aubyn Street
The St Aubyn family chose many of the street names that appear in the area and many of these were named after well-known Navy and Army personnel. Nelson House was named after Vice Admiral Horatio Lord Nelson. The building, as well as the rest of St Aubyn Street, disappeared many years ago.

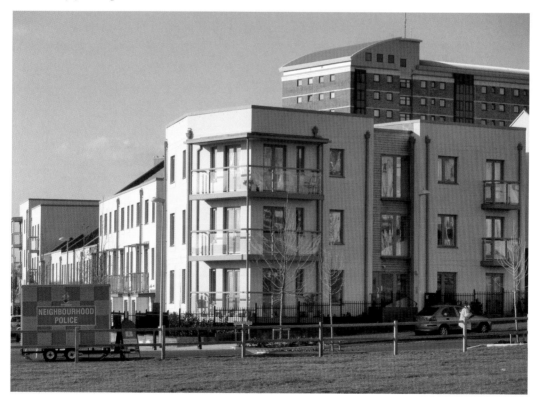

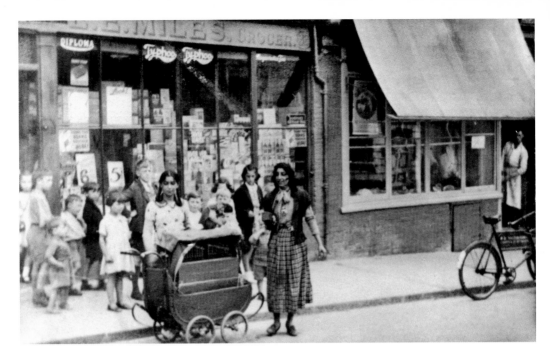

Barrel Organ and Monkey at Cumberland Street

The older photograph shows an Italian woman with her daughter complete with monkey and barrel organ. Many children have gathered to watch the fun and a shopkeeper peers out of a doorway nearby. The older woman has a small collection box. The grocery store in the background belonged to Mr E. B. Miles.

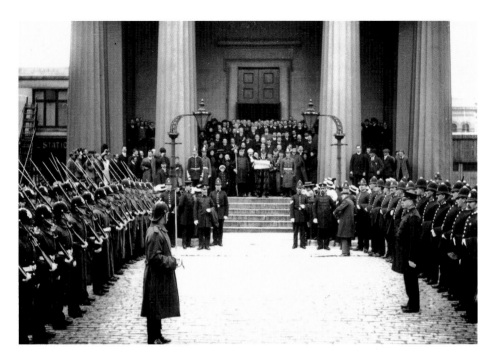

Function at the Guildhall

Policemen and military personnel carrying rifles gather at the Guildhall as the Lord Mayor reads a proclamation of King George V on 10 May 1910. The Mayor at the time was Alderman Littlejohn JP. The police station is to the left of the Guildhall and to the right was the Ker Street Infants School.

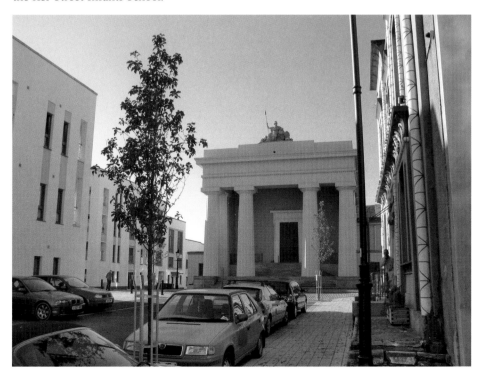

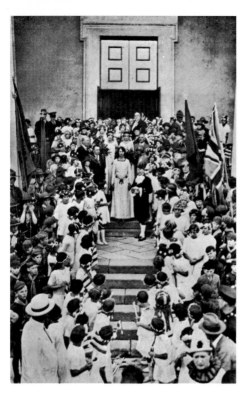

Queen Devonia at the Guildhall

Harry Harcourt, who was the manager of the Tivoli Picture House, can be seen dressed as a circus clown in the older photograph. He would join the procession and would collect funds to help the Royal Albert Hospital. The photograph was taken in 1929 and features members of the scouts together with many maids of honour complete with flowers in their hair.

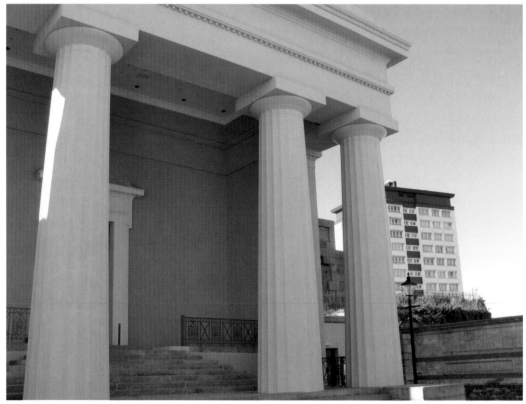

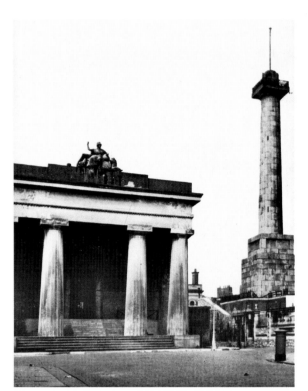

The Guildhall and Column

The Guildhall and Column were designed by John Foulston in the early 1800s. The Guildhall was built in 1821 and was followed by the Column in 1824. The Oddfellows Hall, across the way, was built in 1823. The iconic Guildhall has now re-opened its doors after a renovation costing £1.75 million.

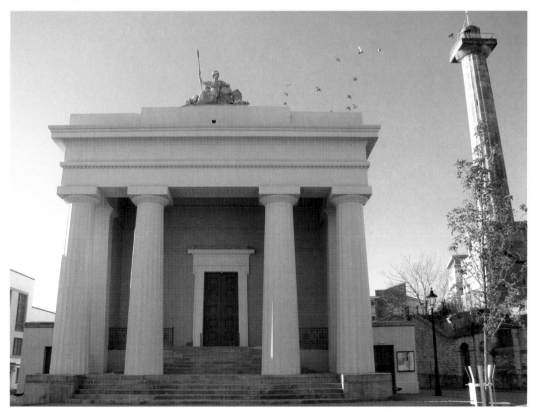

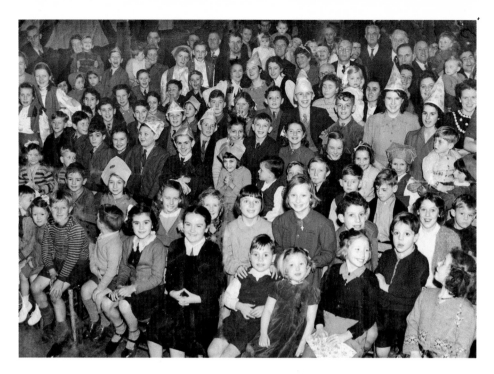

A Christmas Party at the Guildhall, 1947

The Co-operative arranged a Christmas party for children within the Guildhall in 1947. Many civic functions, carnival events and parties took place in the Guildhall over the years. During the Second World War, the Guildhall was used as a centre for distributing gas masks to the people of Devonport. Fortunately, the feared gas attack never occurred.

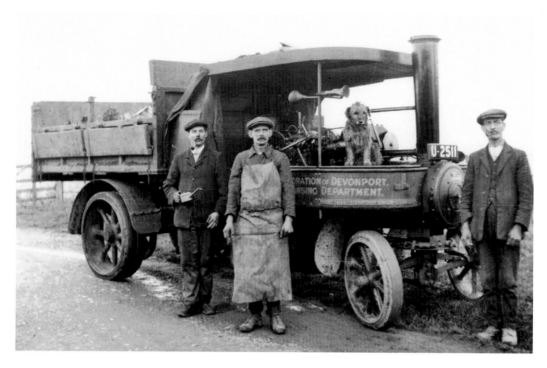

Workers of the Corporation of Devonport Cleansing Department

Three workers of the Corporation of Devonport Cleansing Department, complete with their small dog, can be seen in the older photograph. Their lorry, which is steam-driven, must have given a pretty bumpy ride as it has no modern-day tyres. The later photograph shows a vehicle belonging to the ground workers at Devonport Park.

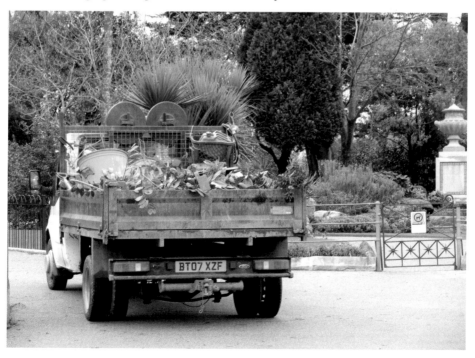

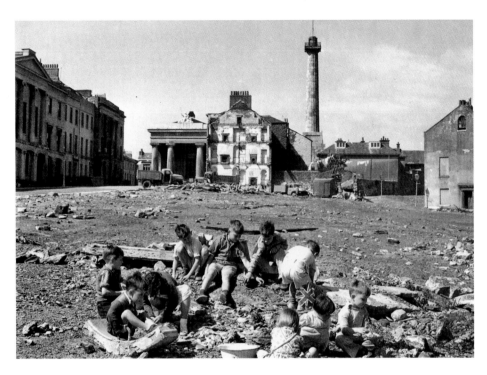

Children Playing Amongst the Ruins in Ker Street

Until the early 1800s, the area was known as Windmill Hill. Terraced houses were built in Ker Street in the 1820s but were damaged in the Blitz. Some properties survived until they were demolished in the 1960s and were replaced with poorly-planned blocks of flats. Today, the old flats are gone and modern dwellings stand in their place.

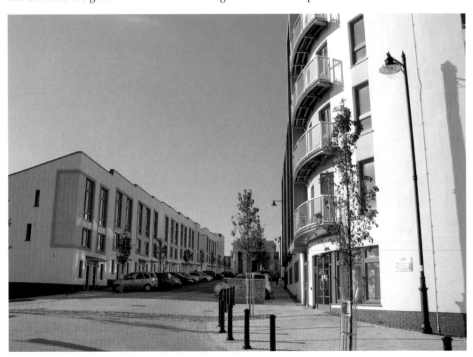

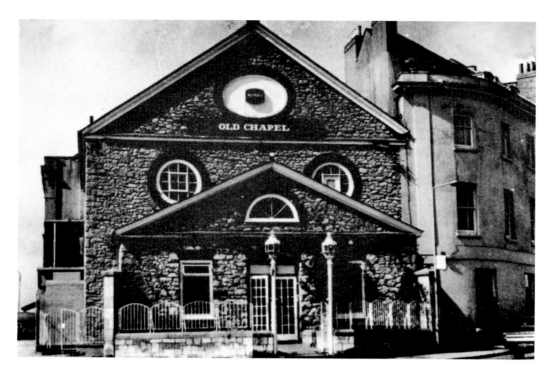

The Old Chapel

The Old Chapel in George Street was built in 1790 and served as a nonconformist Unitarian chapel. It was converted into a public house in 1801 and remained in business until the late 1980s. The building fell into a state of disrepair in the 1990s but was refurbished and re-opened as a convenience store in 2000. It was listed as a Grade II building in 1954.

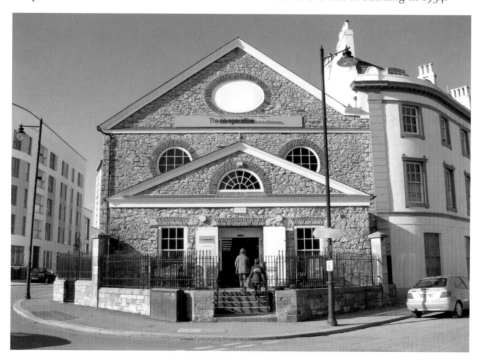

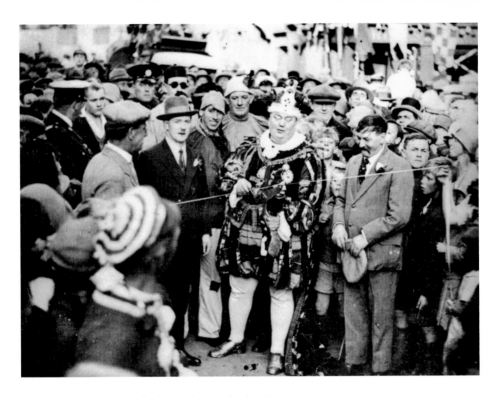

Putty Philpotts as Carnival King in Pembroke Street
Putty Philpotts cuts the ribbon to commence the carnival at Pembroke Street. He was well-loved and was described as 'a giant of a man'. As well as serving in the Royal Navy, he was also a doorman at the Palace Theatre and the landlord of the No Place Inn at Eldad Hill in Stonehouse.

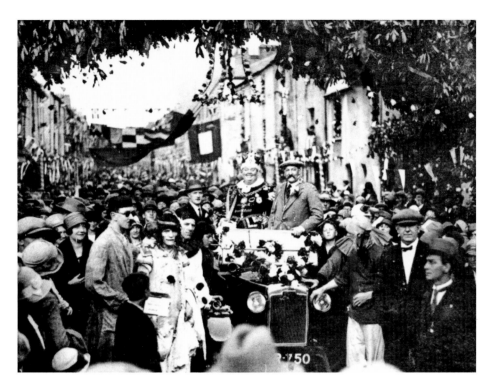

The Carnival Procession at Pembroke Street

Putty, as carnival king, can be seen again being driven through the crowds at the carnival by Harry Taylor. A bell made of flowers hangs from the leafed arch stretching across the street. Several members of the crowd are wearing fancy dress. The street is festooned with decorations for the occasion.

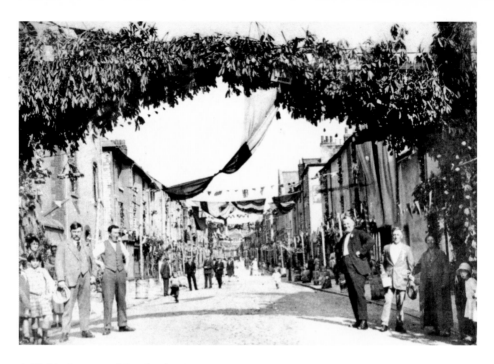

A Highly Decorated Pembroke Street

The carnival can be seen in the older photograph taking place in 1928. Local cinemas and theatres sponsored the carnivals to help the unemployed. The last carnival before the war was in 1939 before air-raid shelters and static water tanks were erected in Devonport Park. There was no further celebrating in the park until the 1945 victory dances which were held in the Nissen huts that had been previously erected by American servicemen.

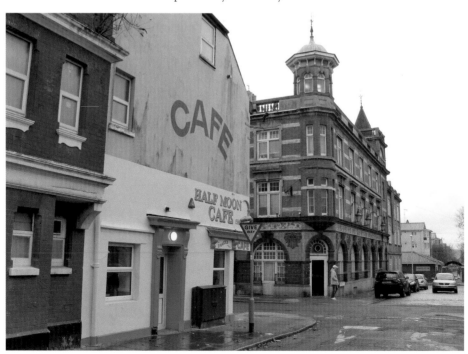

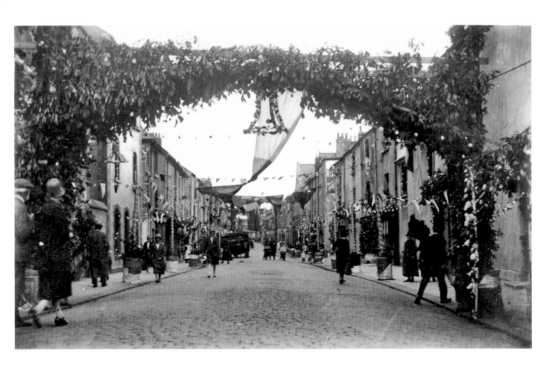

Festooned Houses, Pembroke Street

Highly decorated houses can be seen in Pembroke Street in the earlier photograph. Much has changed over the years and the area is unrecognisable today. The revellers would proceed to Devonport Park where many people would gather to see the crowning of the Carnival Queen. Once the crowning had taken place, the Carnival would be declared open.

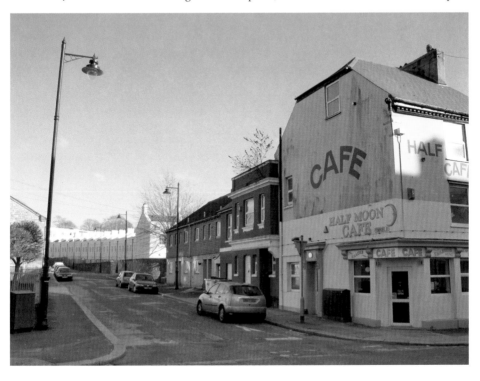

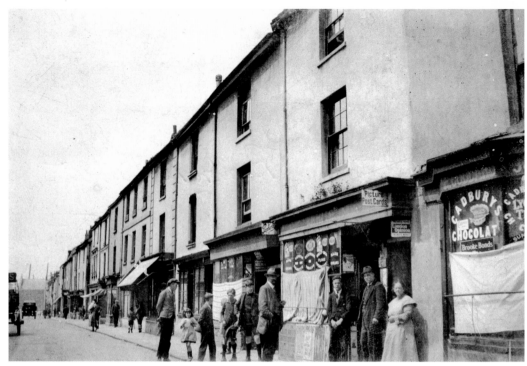

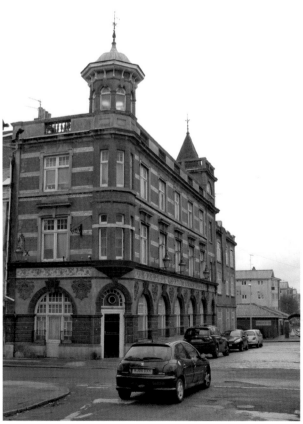

Shops at Pembroke Street

There is much going on in the older photograph taken in Pembroke Street. An advert for the *London Opinion* described as 'the witty weekly' can be seen on the shop selling cigars and picture postcards which appears to belong to 'Stephens'. The boy nearby is carrying a metal bicycle wheel. The grocery shop on the right, belonging to E. Goddard, has adverts for Bird's Custard, Cadbury's Chocolate, Sunlight Soap and both Lyon's and Brooke Bond Tea.

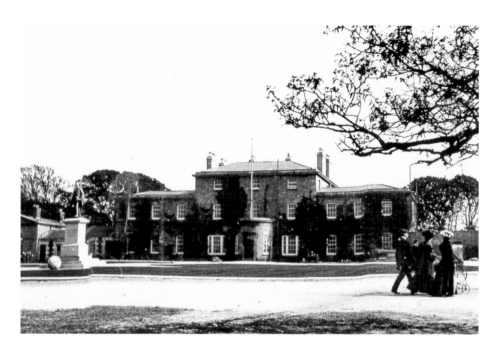

The Admiral's Seat, Mount Wise

The earlier photograph shows the original Admiral's seat at Mount Wise. When the nearby Government House became available in 1935, the Commander-in-Chief, Vice Admiral Sir Eric Fullerton, moved there and renamed the building Admiralty House. The recent photograph shows the later Admiralty House which was later handed over to the War Department and renamed Hamoaze House. The original Admiralty House is currently being developed into luxury dwellings and a hotel.

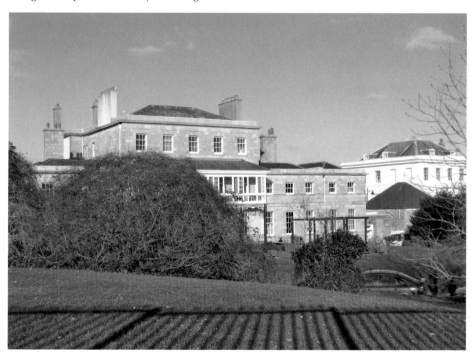

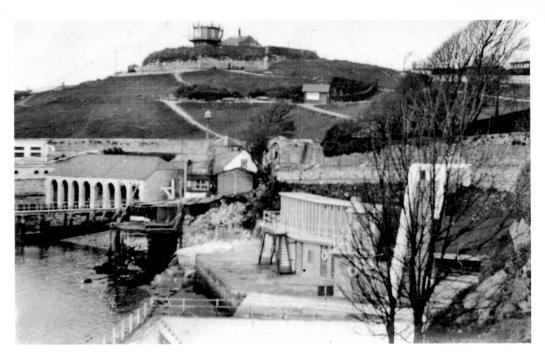

A View across Mount Wise

The earlier photograph shows the original pools that once stood at Mount Wise. The arches of the building on the left still stand although the roof has long since disappeared. The later photograph shows the view from the area around the mast on the nearby hill looking towards the flats at James Street.

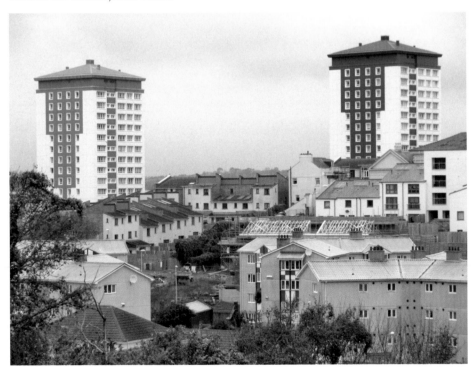

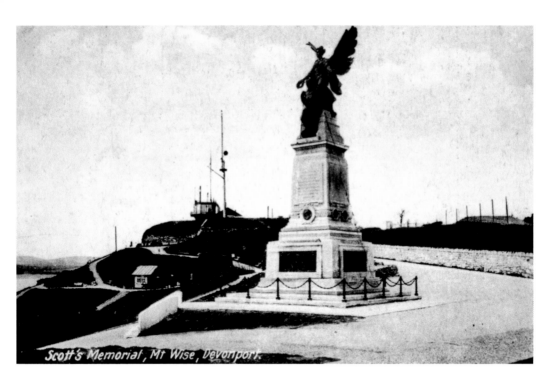

Scott's Memorial, Mt Wise, Devonport.

Scott's Memorial, Mount Wise

The memorial commemorates Captain Robert Falcon Scott and his comrades who died while returning from the South Pole in 1912. Scott was from Plymouth and his family home, 'Outlands' once stood beside where Outland Road stands today. The statue features an angel with outstretched wings and is positioned near to Admiralty House.

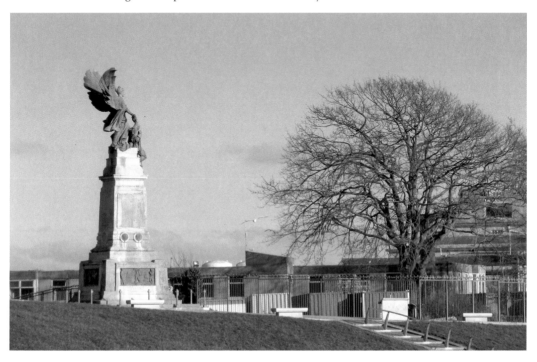

Houses at Richmond Walk, Mount Wise
Richmond Walk was opened as a promenade in 1809 and was known as 'poor man's corner' by many locals. The earlier photograph shows the houses on the waterfront. Much has changed over the years including the demolition of Bromley Cottages in 1953. More recent wooden buildings can be seen in the later photograph.

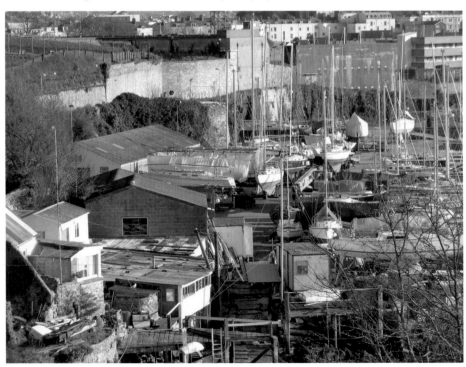

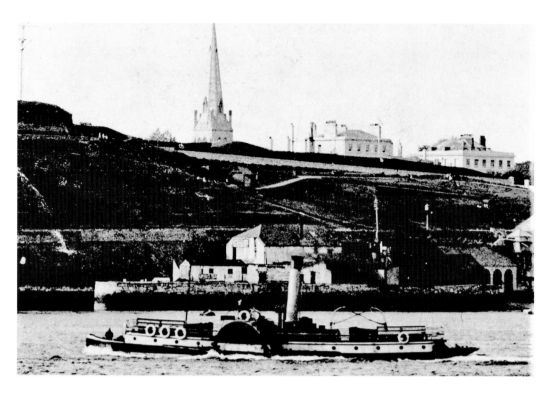

A Paddle Steamer Passing Mount Wise

An advert for Lipton's Tea can be seen on one of the buildings in the background. A semaphore signalling station was built at Mount Wise in 1810 and was used to pass signals to ships moored in the Sound and the Hamoaze. The electric telegraph was introduced in 1852 and replaced the old system.

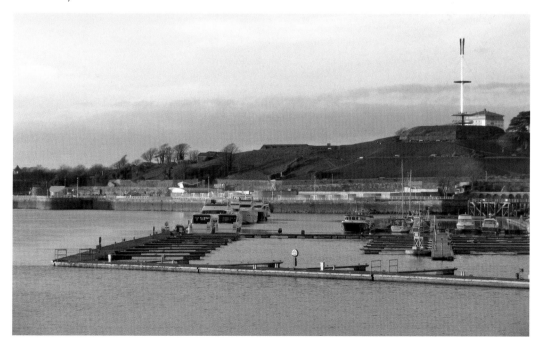

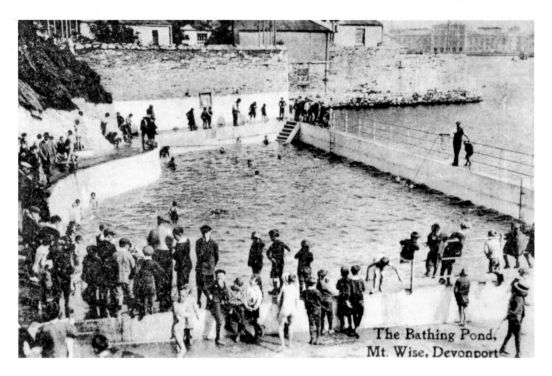

The Bathing Pond at Mount Wise

The older photograph shows many Victorian children enjoying a paddle at the bathing pond at Mount Wise. A man on the right has a rope tied to a young boy as he learns to swim. The swimming baths were free to men and boys and the pond was known as 'Pikeys'. Canadian Army Engineers filled in the pools many years later.

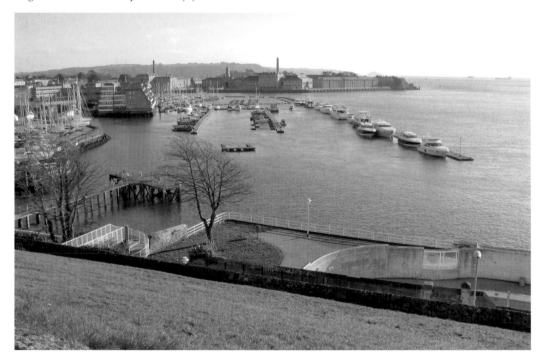

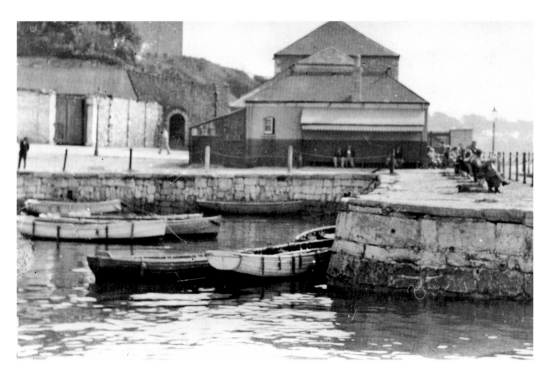

Boats at Mutton Cove

The watermen at Mutton Cove would take people over to Mount Edgcumbe for the day where they would pay to enter at the stile near the beach. Many visitors would head towards the hill where the obelisk stands and enjoy the view and have a picnic. Sailors were also taken back to their ships by the watermen.

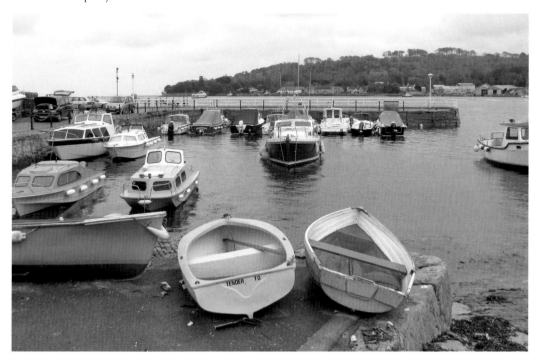

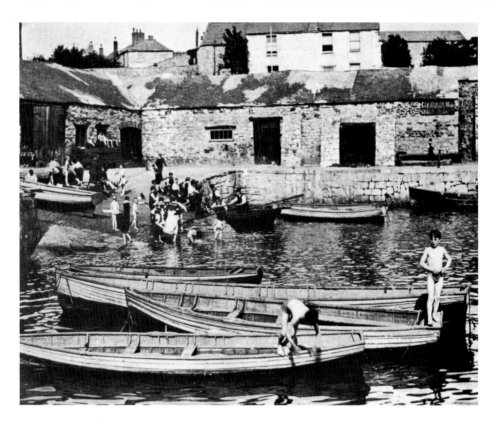

Children Swimming at Mutton Cove

The earlier photograph shows many children swimming in the harbour at Mutton Cove. Two boys are diving from the eighteen foot boats that were moored there. The boats were used in the annual Galas and Carnivals. The houses in the background are in James Street and are now all long-gone.

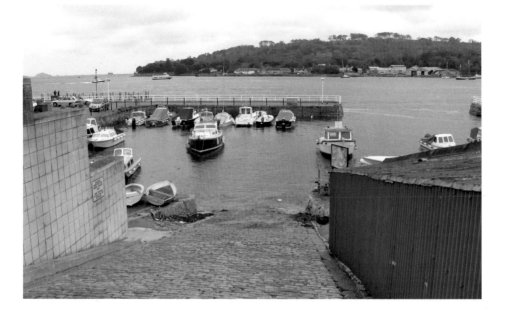

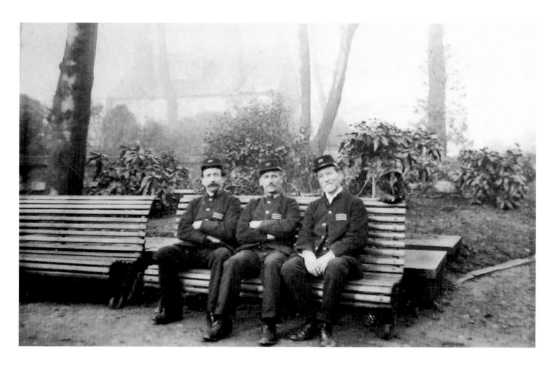

Three Men Taking it Easy at Devonport Park

Three military men relax in the gardens perhaps waiting for a military troop to play at the bandstand. Devonport Park has been restored to its former glory at a cost of £5.2 million and the final stage, through voluntary collections, is to replace the bandstand which was dismantled in the 1950s.

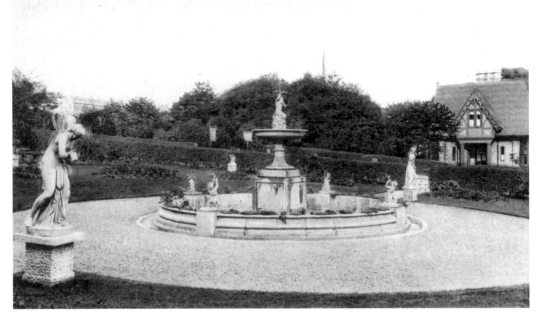

The Fountain at Devonport Park

The fountain was originally built as a memorial to Admiral Sir Charles Napier in 1863. Napier was much-admired by naval personnel and hundreds of sailors and marines donated a day's wage to fund the building of the fountain. For many years, it stood in a state of disrepair but has now been beautifully restored to its former glory.

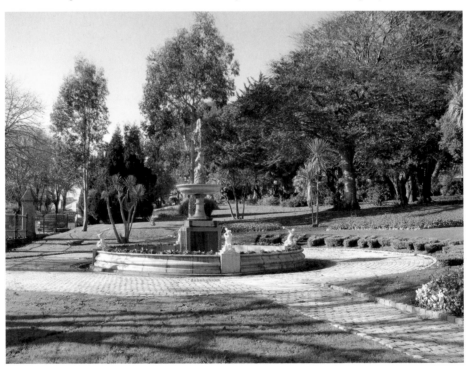

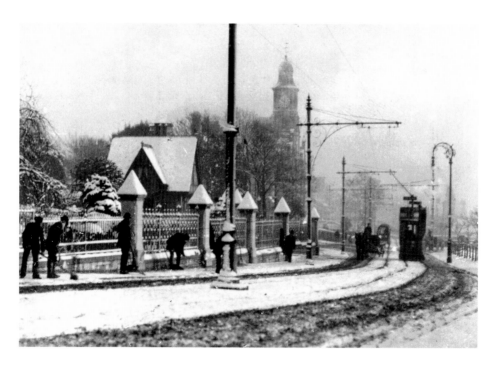

Snow at Kings Road by Devonport Park

Snow covers Kings Road in the older photograph as a tram struggles up the hill. The Technical College can be seen in the background. The Swiss Lodge looks aptly placed as men nearby busily clear the pavement. The layout of the road today is much the same but is much busier with modern traffic.

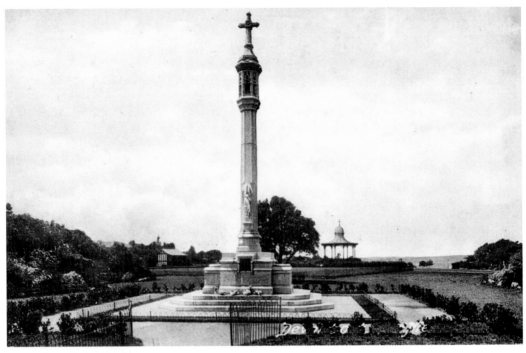

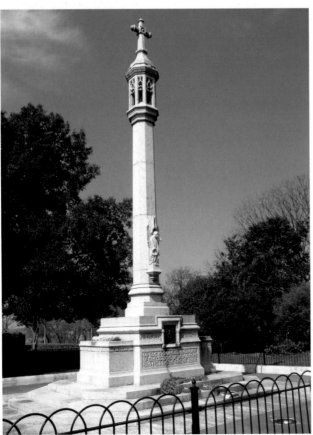

The War Memorial at Devonport Park

A crest recognises the Royal Flying Corps who came into existence in April 1918 and similar crests commemorate the Royal Navy and Army. In the background of the older photograph is the bandstand in all its former glory. The memorial carries the words, 'To the immortal memory of the citizens of Devonport who fell in the Great War.'

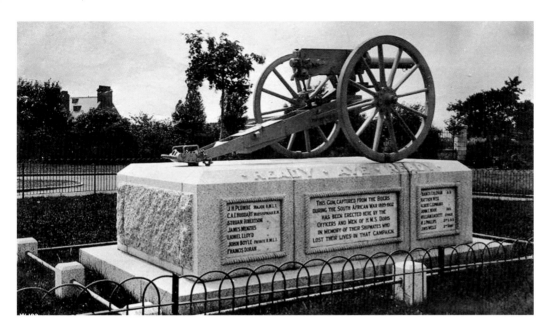

Old *Doris*, Devonport Park

On the plinth below the gun are the words, 'This gun captured from the Boers during the South African War 1899–1902 has been erected here by the officers and men of HMS *Doris* in memory of their shipmates who lost their lives in that campaign.' Also on the plinth are the names of the men who lost their lives and, carved into the stone, are the words, 'Ready Aye Ready'.

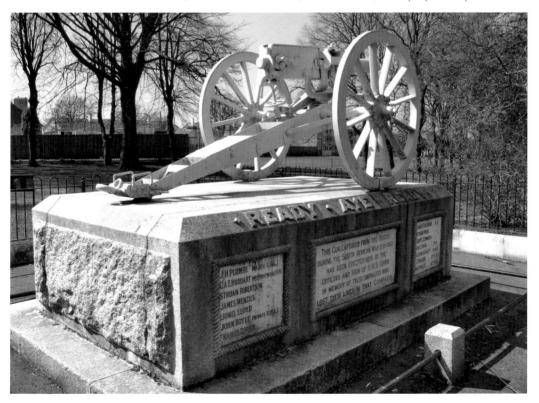

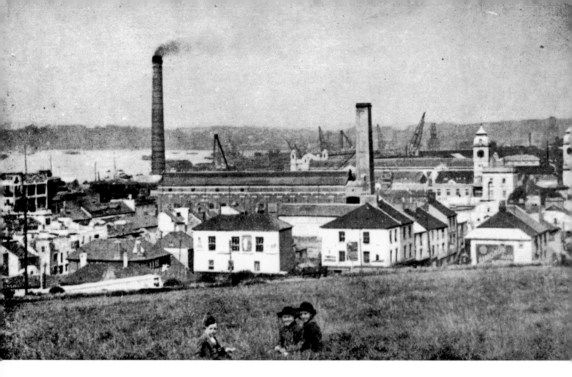

Looking Towards the Dockyard from Devonport Park

Three children have a picnic in the long grass at Devonport Park. Before the road cut through it, the park stretched right down towards Pottery Quay. Much has now disappeared in the background of the older photograph and some areas of the dockyard have changed vastly. One of the huge hangars, built in the 1970s, dominates the view in the later picture.

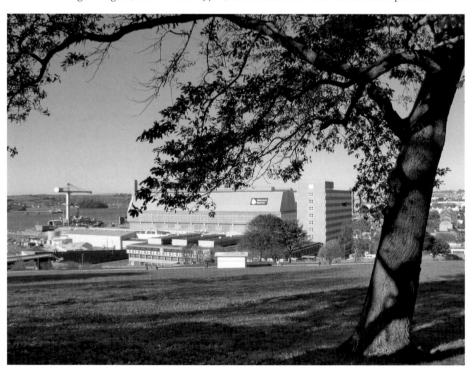

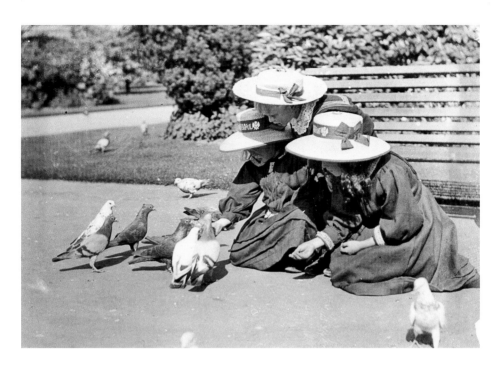

Feeding the Pigeons at Devonport Park

Three young girls feed the hungry pigeons breadcrumbs in a corner of Devonport Park in the early 1900s. Their boaters have the names of naval ships on them including HMS *Powerful* and HMS *Dreadnought*. Sailors wore similar hats in the early 1900s and these could belong to the girls' fathers.

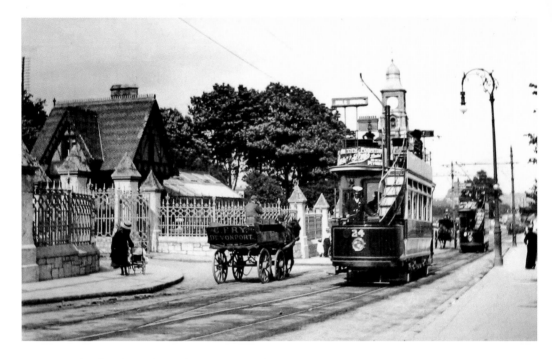

Trams Passing by the Swiss Lodge, Kings Road

The Swiss Lodge, at the entrance to Devonport Park, was built in 1858 and was once the home of the ground keeper. It was designed by Alfred Norman in the Swiss-style to represent the new park being a place for healthy recreation. It is Grade II listed and has recently been restored to its original condition.

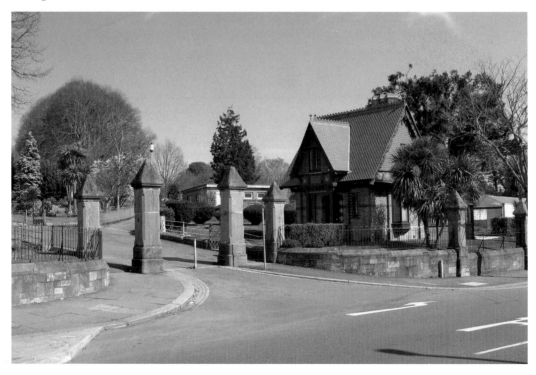

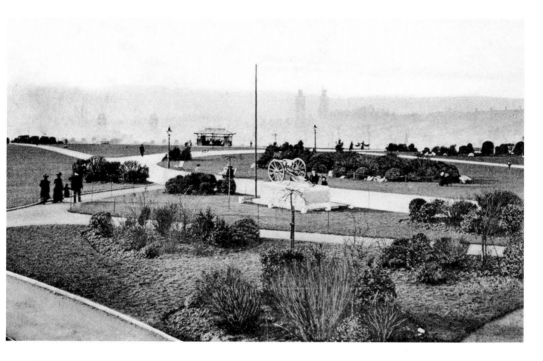

A View of Devonport Park Looking Towards the Dockyard

The *Doris* Gun can be seen in the middle of the older photograph. In the mist, in the background, can be seen the towers within the dockyard. The layout of the park has changed over the years but the gun still stands in the same position. A small paddling pool once stood nearby but this was filled in many years ago and no trace of it remains.

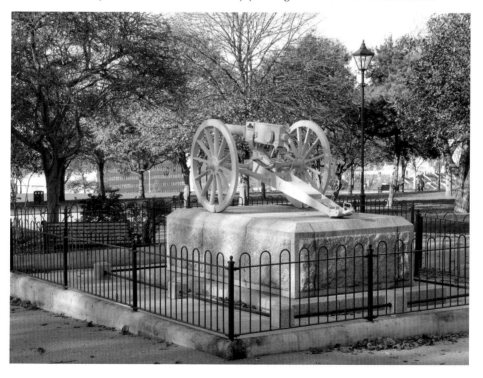

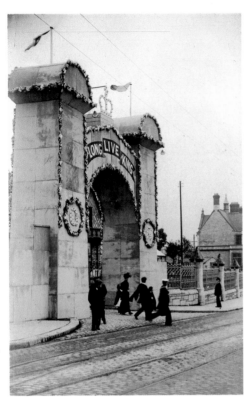

A Decorated Entrance at Devonport Park
The ornate structure in the earlier photograph
once stood at the entrance of Devonport Park
near to the Swiss Lodge. It was decorated
for George V's coronation in June 1911 and
a banner announces 'Long Live the King'.
Although very grand, the entrance appears
to be a temporary one and has disappeared
in later photographs taken around about the
same time.

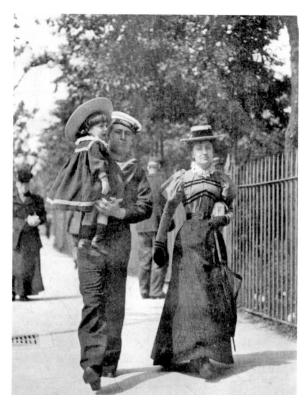

A Family Walking beside the Park
A young sailor, together with his wife and small daughter, head towards the entrance of Devonport Park. The little girl is wearing a sailor-type outfit which were very popular at the time. Her mother is dressed in her Sunday best complete with ribboned boater, gloves and a parasol for the sun.

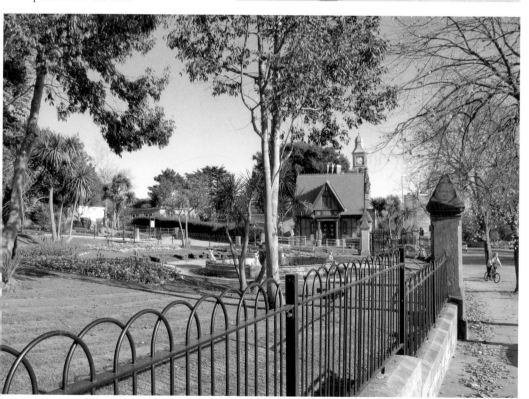

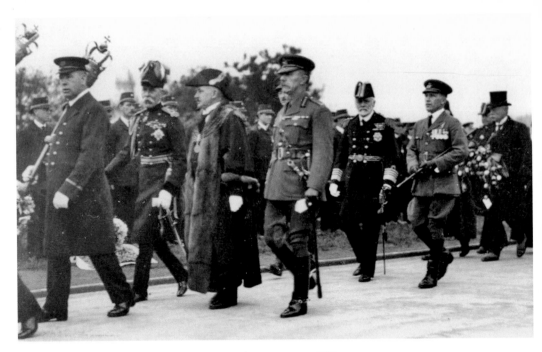

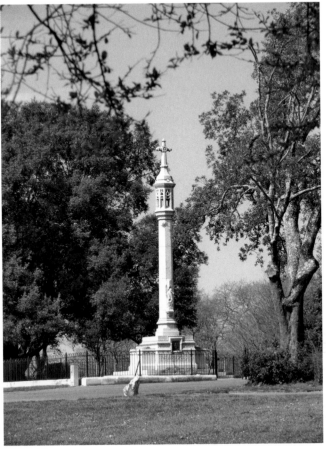

A Ceremony for the War Memorial

Devonport unveiled its own War Memorial in 1923. It commemorates the soldiers, sailors and airmen of Devonport who lost their lives during the First World War. The early photograph shows stern-looking, high-ranking officers together with city dignitaries, including the Lord Mayor, on their way to the ceremony at Devonport Park.

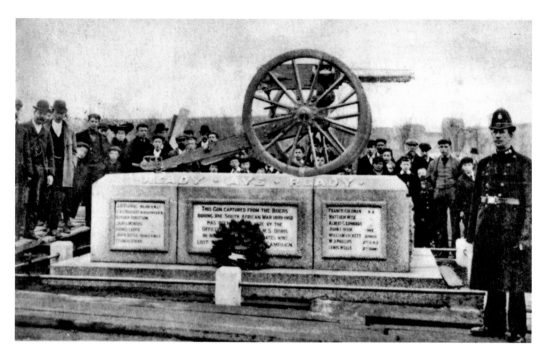

A Gathering by the *Doris* Gun

Spectators have gathered in the earlier photograph to see Devonport's first war memorial erected. A wreath has been laid beneath the *Doris* Gun. The gun seen in both photographs was captured in the Boer War in 1900 and commemorates the naval personnel of HMS *Doris* who died in the conflict. The gun was unveiled in 1904.

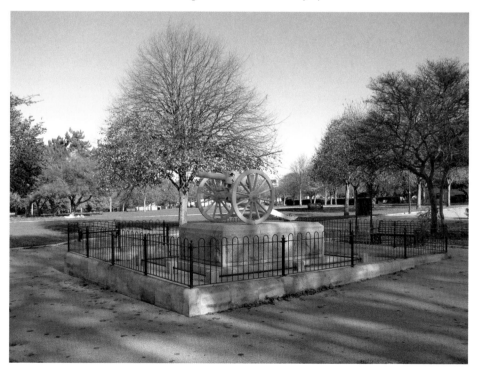

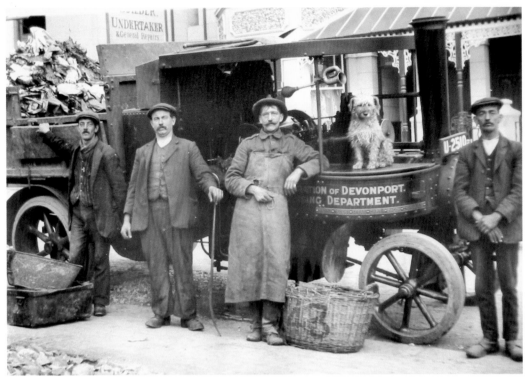

Devonport Workers and their Dog
In the earlier photograph, workers of the Devonport Cleansing Department pose with their vehicle. The men were responsible for keeping the streets clean of discarded rubbish, horse droppings and leaves. A basket used for the purpose can be seen beside one of the workers. The later photograph shows fallen autumn leaves outside Devonport Park.

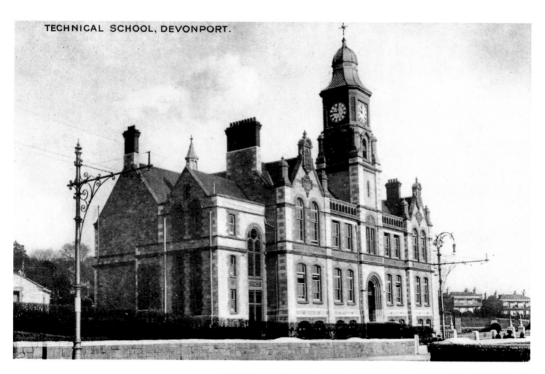

The Technical School in Paradise Road

The Technical College was built in 1897 and included classrooms, a lecture room and workshops for students to learn a trade. From 1898 until 1936, it also housed the Devonport Municipal Secondary School for Girls. It became an annexe to the nearby College of Further Education but closed in 1990 before being developed into luxury apartments.

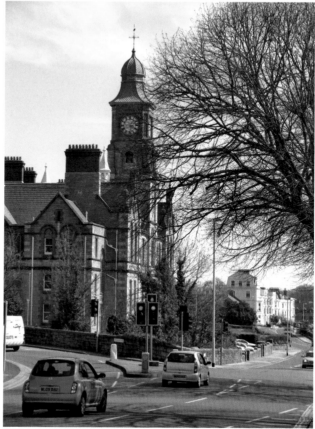

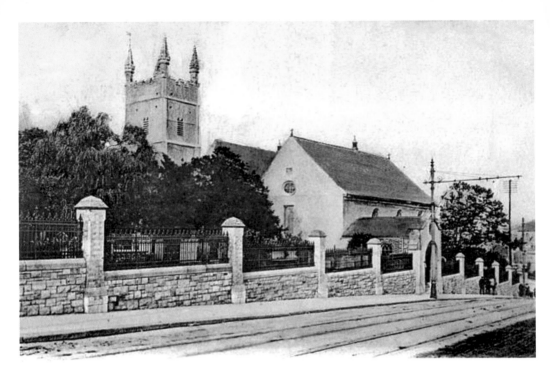

Stoke Damerel Church

Situated in Paradise Road, the earliest record of the church is in the taxation records of Pope Nicholas IV of 1288. During the removal of graves in the 1950s, some of the headstones were laid flat to form a path. One of the headstones belonged to Cornelius Tripe, who was the Mayor of Devonport between 1838–1839.

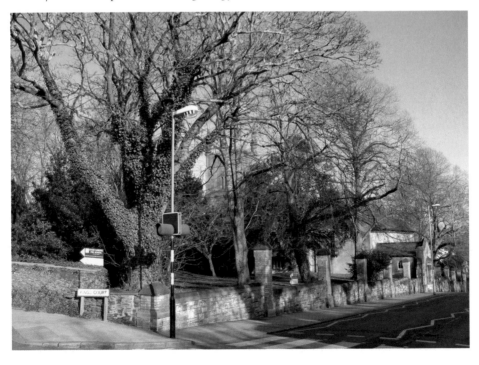

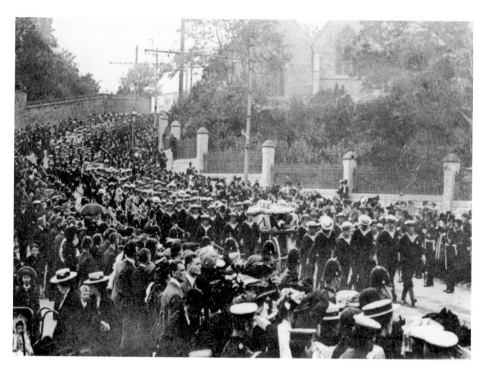

A Funeral Procession Passing by Stoke Damerel Church

The funeral procession is for the crew of the A8 Submarine Boat Disaster which was lost in Plymouth Sound on Thursday 8 June 1905. Fifteen crew members died. The procession started at the dockyard on its way to its destination at Ford Park Cemetery. Tens of thousands of people lined the route to pay their respects.

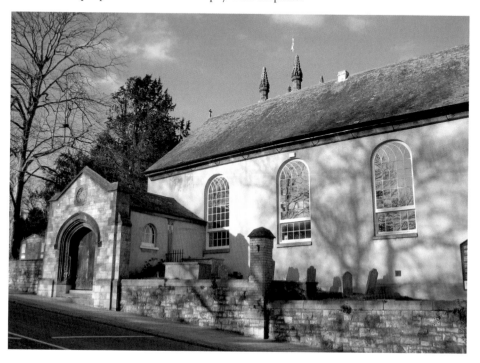

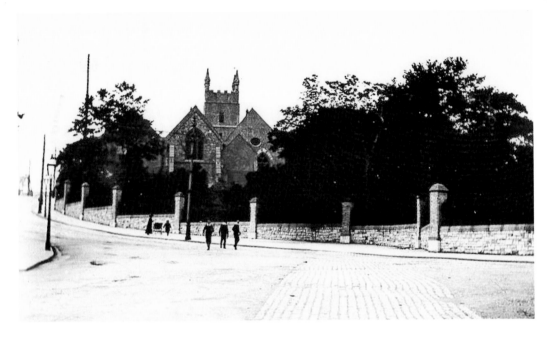

Stoke Church from Fellowes Place
The cobbled road has long-since disappeared beneath tarmac and the view of Stoke Church and its tower, from Fellowes Road, is now obscured by tall trees, although it can be seen clearly further along Paradise Road. The earlier photograph shows a very quiet scene in the days before modern traffic.

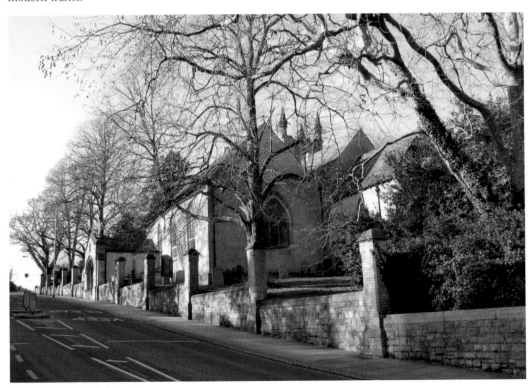

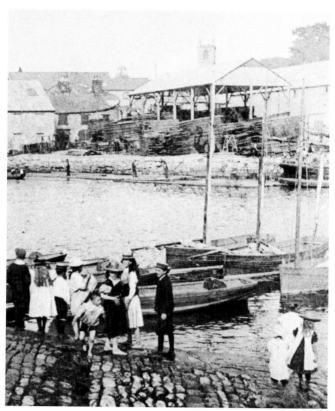

Children Gathered at Ocean Quay

Children play on the cobbled slipway at Ocean Quay in the older photograph. Most are well-dressed and wearing their finest hats. Ocean Quay railway station was used extensively by passengers disembarking from the many luxury liners that once called at Plymouth. Today, apartments stand at Ocean Quay complete with many impressive motor launches and yachts.

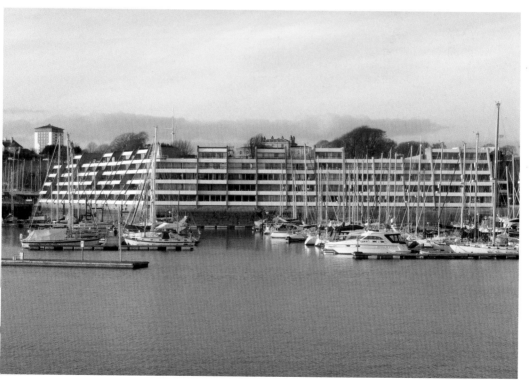

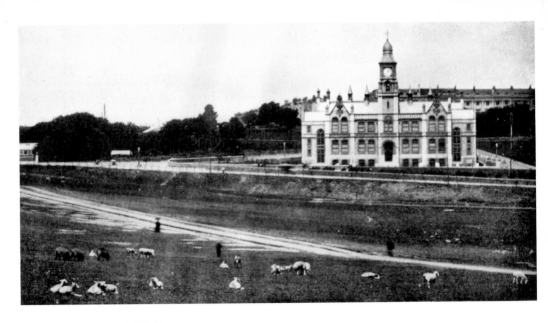

Sheep Grazing at Brickfields

It was once a common site to see sheep grazing at Brickfields which is now a sports centre and recreation ground. Two tigers escaped from a circus here in 1930 and one was later spotted in Devonport Park. The later view looks from Stonehouse Bridge towards the old technical school in Paradise Road.

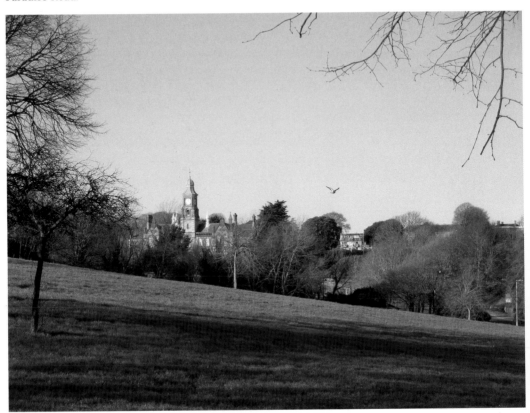